RMS QUEEN ELIZABETH

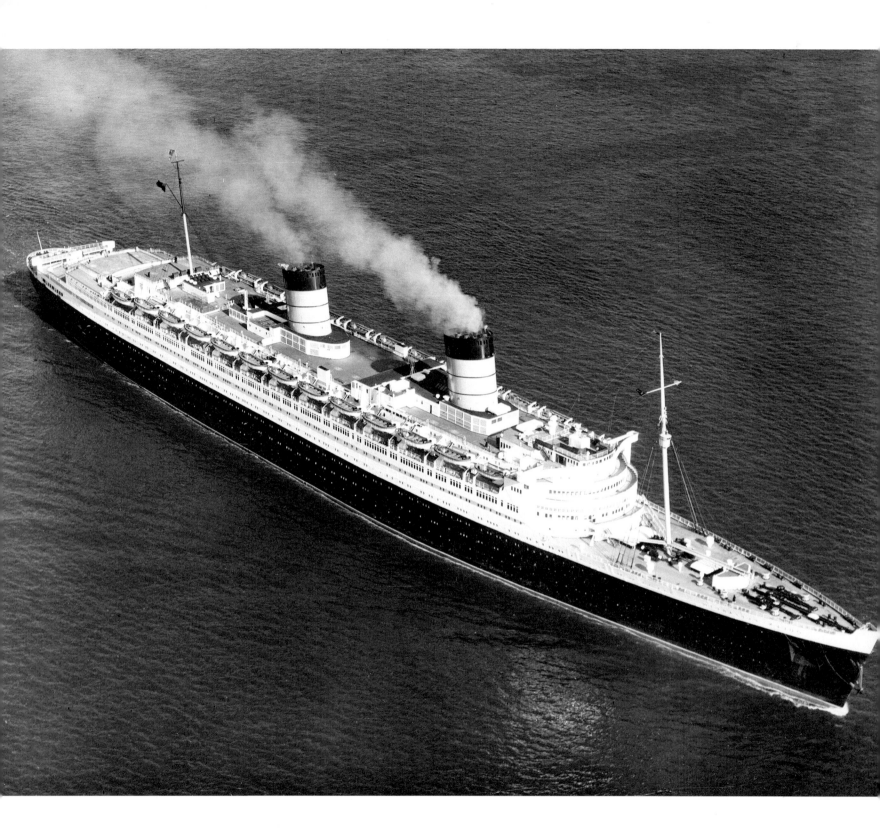

RMS QUEEN ELIZABETH

ANDREW BRITTON

The History Press

First published 2013
Reprinted 2022

The History Press
97 St George's Place,
Cheltenham, Gloucestershire, GL50 3QB
www.thehistorypress.co.uk

British Library Cataloguing in Publication Data.
A catalogue record for this book is available from the British Library.

ISBN 978 0 7524 7951 4

Typesetting and origination by The History Press
Printed by TJ Books Limited, Padstow, Cornwall

Frontispiece: A superb aerial action view
of *Queen Elizabeth* sailing off the coast
of Ireland having briefly stopped at Cobh.
(Associated Press)

CONTENTS

QUEEN ELIZABETH

LIVERPOOL

ACKNOWLEDGEMENTS

This book could not have come into being without the generous help of many people. Three people prompted me to get to work: Commodore Geoffrey Thrippleton Marr, Colin Walker and Uncle Joe Webb. The latter badgered me about this book each and every time I visited or telephoned him!

I owe a great debt of thanks to Jim McFaul of the World Ship Society for his considerable assistance in locating colour slides for this book. Hisashi Noma of the World Ship Society of Japan generously sent many large colour transparencies for inclusion for which I am extremely grateful.

Southampton photographer and author Barry Eagles, Isle of Wight photographer David Peters, Birmingham photographer John Cox, Norwich photographer A.E. Bennett and Sussex photographer John Goss placed their entire collections at my disposal. Similarly, Graham S. Cocks, the Estate of the late Pursey Short, the Estate of the late Norman Roberts, the Estate of the late Gwilym R. Davies, the Estate of the late Arthur Oakman, Esso and Cunard have very generously donated their maritime photographic works to the care of the Britton Collection for inclusion in this and other books.

Considerable assistance has been received from the United States of America from David Boone, Ernest Arroyo and Bill Cotter, who have allowed me to use their original colour slides for inclusion in this book.

The Associated Press, *Chicago Tribune*, *New York Times*, *Washington Post*, US Press Historical Images and the United Kingdom's *Daily Mirror* have emptied their drawers and archives to send me their original photographic prints, original negatives and press copy. This extraordinary contribution is gratefully acknowledged.

A huge thank you must be extended to Commodore Ron W. Warwick who made available to me the Night Record Log book and the records of his late father, Commodore William 'Bil' Warwick.

I would like to express my thanks to the late Commodore Geoffrey Thrippleton Marr, Second Officer Bert Jackson, First Class Steward Bernard Webb and my Uncle Joe Webb for allowing me to record their reminiscences and make notes. I only hope that I have done their memories justice. To Uncle Joe, in particular, I owe a great deal of thanks for sowing the seeds of this book.

As always, my brother-in-law Mike Pringle has meticulously scanned and restored the slides and illustrations included here. Additionally, Mike has photographed the original paintings, diagrams and sketches. My sister Ruth's help has been invaluable.

One person who has monitored the progress of this book and proofread the text is Michael Jakeman. He has once again proved to be invaluable with his sharp eye for detail and knowledge of all things nautical.

I must say a big thank you to my wife Annette for supporting me on a daily basis when researching and writing this book, and also to my sons Jonathan, Mark and Matthew for all their help.

INTRODUCTION

Sometimes in life we make promises that take a long time to keep. Many years ago I made a promise that has taken much longer than anticipated to fulfil to three very special, but different, men who loved the largest passenger liner in the world, RMS *Queen Elizabeth*.

Commodore Geoffrey Thrippleton Marr was the last master of *Queen Elizabeth* until their mutual retirement in 1968. His words still ring in my ears: 'Don't let them forget my ship. Why don't you write a book fit for a queen? She deserves a fitting tribute.'

Back home in Warwickshire, during my teaching career, I received regular visits to my school from photographer, author and friend Colin Walker. Each time he called into my classroom with a student teacher on placement, the conversation would soon change to steam trains and shipping. Following his retirement, I visited Colin at his new home in Wales with my wife and son Matthew. He asked me to write a book about his favourite ship, RMS *Queen Elizabeth*.

'I tried to show what *Queen Elizabeth* was like in black and white in my book, *Memory of a Queen*, on a voyage from Southampton to Cobh. Now it is up to you to continue her story with colour.'

I did not know at the time that these would be Colin's last words to me, for shortly afterwards he passed away.

Visits to my Uncle Joe in Southampton ensured that I would not forget *Queen Elizabeth*. 'When are you going to write a tribute to the *Queen Elizabeth*? She was the finest ocean liner on the Atlantic. I still say that if we could have fully steamed every boiler and opened all her valves, the *Lizzie* could have won the Blue Riband back,' my Uncle Joe would say. What appears in this book fulfils my promise to these three gentlemen.

From as long back as I can remember, my father instilled a deep love for *Queen Elizabeth* in me. I can still vividly remember the sight, sound, smell and feel of her. Like so many, I took her for granted as I looked upon her as an everyday part of my formative years. My Uncle Joe would often proudly recall working on her. We would go down to picnic at Mayflower Park in Southampton or sit at the end of Hythe Pier to watch her arrive and sail. Even when she was undergoing a refit in the King George V Graving Dock, *Queen Elizabeth* was just part of the scene as I played on the swings at Millbrook with my sister and cousins. Even when I was in my bed in our caravan on holiday at Beaulieu Road Station, I could hear her deep booming whistles calling out to me. Perhaps more than with any other ship, I have always had a deep emotional bond with this magnificent liner.

Looking back to 29 November 1968, who would have believed that it would be the final farewell from Southampton, as RMS *Queen Elizabeth* sailed majestically past the waiting crowds at the viewpoint on Western Shore at Netley? Few were there on that dull, depressingly damp autumnal morning to watch and witness the *Elizabeth* as she slipped silently away down Southampton

Water towards Calshot and the Isle of Wight for the last time. The few ships in Southampton Docks did salute as the *Queen* passed, with her escorting tugs giving three long blasts on their whistles. Sadly, RMS *Queen Elizabeth* could not reply as her whistles were out of action. Passing the Nab Tower off the Isle of Wight, the Royal Navy, in the form of the guided missile destroyer HMS *Hampshire*, provided a fitting tribute of 'cheered ship' with her crew manning the rails. These farewells fell far short of those for her elder sister, RMS *Queen Mary*, the previous year. The destiny of the *Elizabeth* lay with a Viking funeral to Valhalla in Hong Kong Harbour.

'If only we could turn the pages of time back to those days and show our children the colour and majesty of what it was like to experience a voyage on *Queen Elizabeth*. She was overshadowed by the departure of her sister RMS *Queen Mary* and did not receive her full and deserved recognition at the time,' Commodore Marr would often lament.

'Gone, but not forgotten. She richly deserves a proper colour tribute,' photographer and author Colin Walker would remind me as he left my classroom.

'You owe it to your dad and the family,' urged former *Queen Elizabeth* crewman Uncle Joe Webb.

Well, at long last, here it is. I have kept my promise. Let us now journey back in time to discover the story of *Queen Elizabeth* with a colour voyage retracing her life and times.

I dedicate this book to my son Matthew, who has joined me at Hythe before sunrise at 5.30 a.m., as the mist is just lifting, to watch the liners come in on the tide. Like me, Matthew loves to hear Uncle Joe's wonderful memories about the liner on which he spent most of his working life at sea, RMS *Queen Elizabeth*.

1

HISTORY

RMS *Queen Elizabeth* was the second of the legendary Cunard *Queen* liners to be built for the weekly transatlantic service from Southampton to New York. In the post-war years she was the largest passenger ship in the world with a registered tonnage of 83,673 and was designed to carry 2,283 passengers in three classes with a crew of 1,296. This magnificent ocean liner was launched by Her Majesty Queen Elizabeth the Queen Mother on 27 September 1938, but it was to be six long years before she was to fulfil her destiny to become the Queen of the Atlantic, working in tandem with her sister, RMS *Queen Mary*.

DESIGN & CONSTRUCTION, 1936–39

It was Sir Percy Bates, then deputy chairman of Cunard, who conceived the visionary idea of constructing *Queen Elizabeth*. He realised that if Cunard were to maintain their premier position on the North Atlantic, then two super liners operating a weekly service would be required. The launch of the first of the new transatlantic liners, RMS *Queen Mary*, had been delayed by the world economic depression of the 1930s, but following her entry into service in May 1936 the focus turned on her running mate. The official contract between Cunard and the government financiers was signed on 6 October 1936.

By this time, the CGT (Compagnie Générale Transatlantique) French liner *Normandie* had entered service and won the Blue Riband for the fastest transatlantic crossing. Sir Percy Bates felt that Cunard could learn something from her interior and hull design, so a member of the architect's design team sailed incognito aboard *Normandie* to spy. Unseen, he carefully took measurements, made discreet notes, sketched interiors and took photographs using a hidden camera. Travelling under the identity of a Liverpool grocer, he was able to ask the French Line staff many searching technical questions about the liner and was successful in gaining considerable access behind the scenes. The English naval architect later revealed: 'I really took a lot of ideas for *Queen Elizabeth* from her. In fact, I think I learned more from her than I did from *Queen Mary*.'

Perhaps the most fundamental design feature gained from the spying mission aboard *Normandie* was the inclusion of a flush deck on the new *Queen Elizabeth*. *Queen Mary* had a well deck and forecastle. A flush deck design, it was thought, could be utilised for tourist passengers. The idea of making the best use of the space between the two funnels was explored. On *Normandie* a full-size tennis court was built, but on *Queen Elizabeth* a tourist lounge deck was drawn into the plans. Space-saving engineers' accommodation and stair designs were copied from *Normandie* and included on *Queen Elizabeth*'s plans.

Lessons were learned from the inadequate design features of *Queen Mary* and improvements were made for the new Cunard *Queen*. Radical improvements

in the design of the boilers, more efficient fuel supply and modern electrical generation were built into the design plan, with the aim of making *Queen Elizabeth* economically more efficient and profitable for the company. The *Elizabeth* was to be fitted with four sets of Parsons single-reduction geared turbines and twelve Yarrow water tube 425psi superheated boilers reaching 750°F. This power input was to propel the quadruple screws at a service speed of 28.5 knots.

Plans were drawn up five months in advance, along with a structured, methodical weekly schedule for the construction. If one section of assembly lagged behind, it could have repercussions on dependent work. It was, therefore, decided in advance to form 'shock brigades' of skilled workers – carpenters, caulkers, riveters and platers – who would be sent in to assist where assembly progress of the ship was falling behind. Her construction number 552, as she was classified, began on 4 December 1936 at John Brown Shipyard on Clydebank in Scotland when her keel plates were laid. By January 1937 the vessel's mid-ship sections were taking shape and attention now turned to the assembly of the bulkheads. Sub-contracts were outsourced for furnishings, furniture, upholstery, paint and electrical fittings. These contracts were lucrative, but had binding penalty clauses. This ensured there were no hold-ups, and the progress and development of construction was kept to a tight schedule.

Visually, *Queen Mary* and *Queen Elizabeth* differed in three key areas: the funnels, the bows and the ventilators. Internally, progress in marine engineering revolutionised the new ship's power system. *Queen Mary* had twenty-four boilers, but *Queen Elizabeth* was equipped with half that amount to provide the same power output to achieve the same speed. More modern methods of ventilation were built in for the air intakes. The huge ventilators visible on *Queen Mary* were therefore absent on *Queen Elizabeth*. This had the knock-on benefit of requiring two funnels

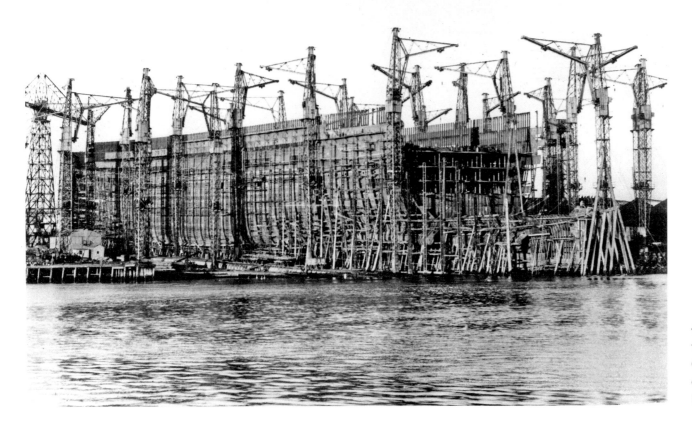

❬ A giant grows on the banks of the River Clyde as number 552 is constructed. (Associated Press)

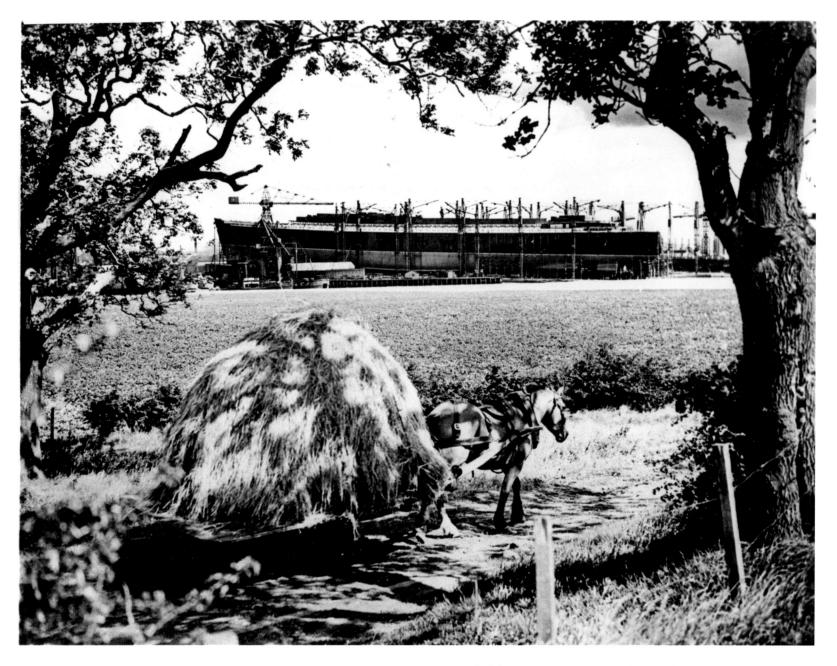

^ A jewel of the sea in a rural setting. The hull of number 552 is on the slipway at John Brown's shipyard as a hay cart rumbles slowly past to lend enchantment to the scene. (Associated Press)

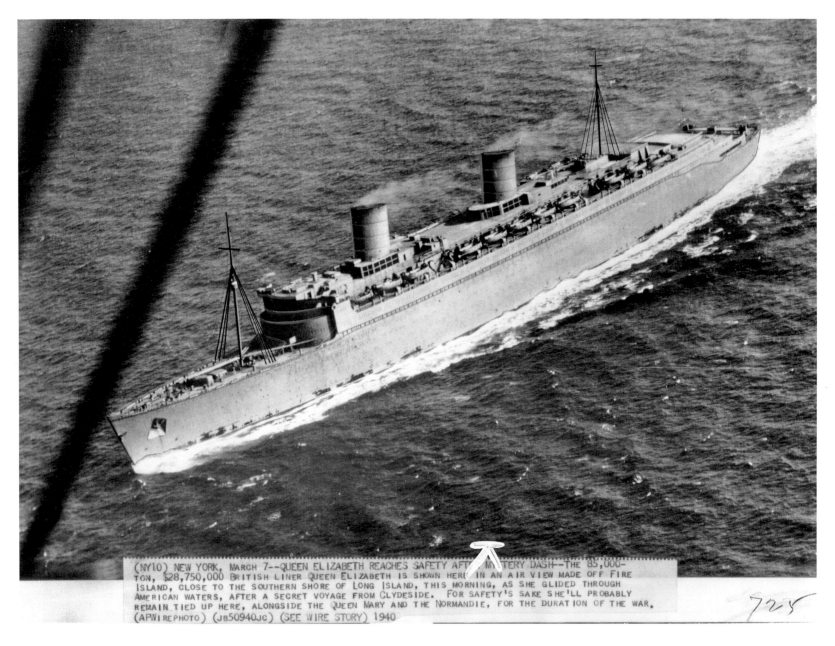

(NY10) NEW YORK, MARCH 7--QUEEN ELIZABETH REACHES SAFETY AFTER MYSTERY DASH--THE 85,000-TON, $28,750,000 BRITISH LINER QUEEN ELIZABETH IS SHOWN HERE IN AN AIR VIEW MADE OFF FIRE ISLAND, CLOSE TO THE SOUTHERN SHORE OF LONG ISLAND, THIS MORNING, AS SHE GLIDED THROUGH AMERICAN WATERS, AFTER A SECRET VOYAGE FROM CLYDESIDE. FOR SAFETY'S SAKE SHE'LL PROBABLY REMAIN TIED UP HERE, ALONGSIDE THE QUEEN MARY AND THE NORMANDIE, FOR THE DURATION OF THE WAR. (APWIREPHOTO) (JB50940JC) (SEE WIRE STORY) 1940

∧ Viewed from a light aircraft off the east coast of the United States, *Queen Elizabeth* is seen on her secret maiden voyage dash across the Atlantic. (Associated Press)

instead of three. Consequently, the total deck space was increased to a size the area of two and a half football pitches. It was also decided to equip *Queen Elizabeth* with a third anchor fitted to the centre of the bow. New special high-elastic steel was included for parts of the ship's hull that were to experience the greatest stresses. Four modern turbo generators built in Rugby were installed to deliver 10,000 kilowatts per hour – enough to power a city of 150,000 people! An advanced and elaborate sprinkler and detection system was designed in case of fire. In total, these new innovations meant that *Queen Elizabeth* would be a far superior vessel – more efficient and profitable for the company.

Number 552 was launched on 27 September 1938 by Her Majesty Queen Elizabeth. The exact time of the launch had to coincide with the peak of the high tide. While waiting for this point for ten minutes, the Queen, Princess Elizabeth and Princess Margaret chatted with Lord Aberconway, the chairman of John Brown's, about the design and construction of the ship. The princesses were shown a small scale model of the ship to demonstrate how she would take to the water. Without warning there was the sound of a crash and the splintering of timbers, and the hull of No. 552 began to move. Her Majesty had pressed the launching button too soon.

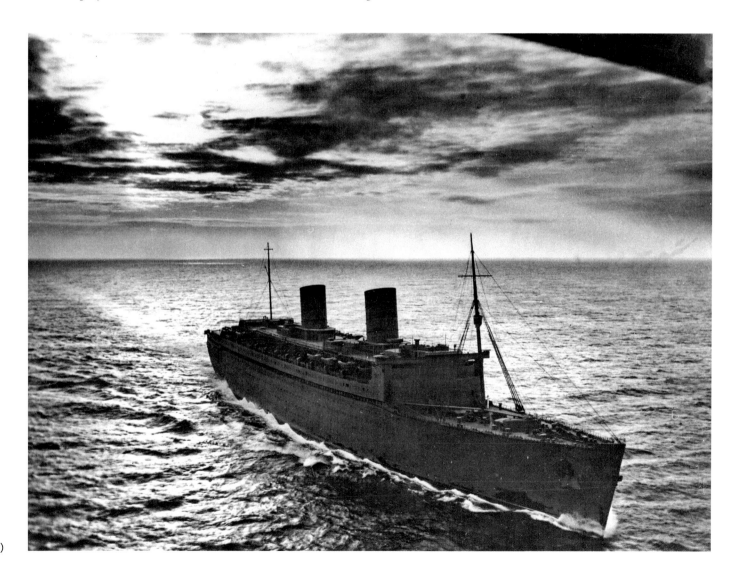

❯ The first sight in the Atlantic of the secret maiden voyage. (Associated Press)

The watching crowd waiting in the rain gasped and shouted, 'She's going!', as the 40,000-ton hull slid down the 900ft slipway. The Queen remained calm and raised her eyes to where the bottle of Empire wine, in red, white and blue ribbons, was still hanging. Instantly she cut the cord and the bottle swung down just in time to catch the extremity of the bows. As it shattered, a tremendous cheer echoed around the yard.

Lord Aberconway leaned across and said, 'Quick, Your Majesty, please name her before she reaches the water.' The Queen smiled and replied, 'It's quite all right. I have done so already.' Apparently, the microphone had stopped working just as she had cut the cord and said, 'I hope that good fortune may attend this great ship and all those who sail on her. I am very happy to launch her and name her *Queen Elizabeth*.'

As the construction of *Queen Elizabeth* progressed, the political situation in Europe deteriorated as the German Führer, Adolf Hitler, increased his demands at Munich in 1938. Cunard's plan had been for the ship to be launched in September 1938, with fitting out to be completed for entry into service in the spring of 1940. It was announced that on 23 August 1939 the King and Queen were to visit the new liner and tour the engine room, and 24 April 1940 was proposed as a date for the maiden voyage. The outbreak of war postponed this and *Queen Elizabeth* lingered at the fitting-out dock in her pristine new Cunard livery until 2 November 1939, when the Ministry of Shipping issued a special licence to declare her seaworthy.

THE MAIDEN VOYAGE & WAR SERVICE, 1939–45

On 27 December 1939 fires were lit and steam was gradually raised in the boilers. The engines were tested for the first time on 29 December between 9 a.m. and 4 p.m., with the propellers disconnected to monitor her oil and steam operating temperatures and pressures. The feedback report found that as with all new machinery it required running in and was tight in places. Extra drip-feed lubricators were installed and the main shaft re-greased. Two months later, Cunard received a letter from the Right Hon. Winston Churchill, then First Lord of the Admiralty. The letter ordered the liner to depart from Clydeside as soon as possible and 'to keep away from the British Isles as long as the order was in force'. This was prompted by the necessity to vacate the fitting-out berth at the shipyard to make way for the Royal Navy's King George V Class battleship, HMS *Duke of York*.

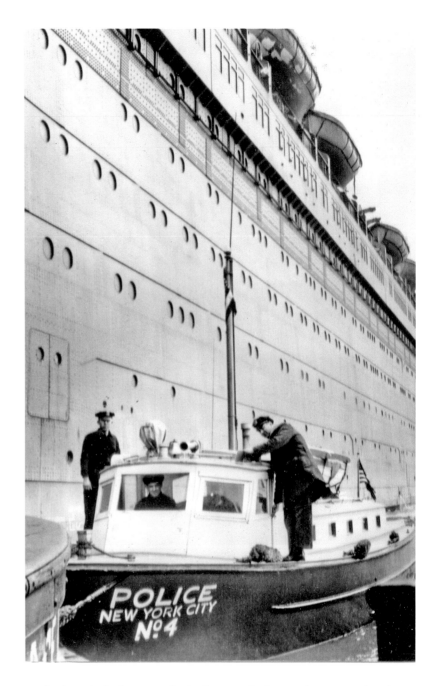

⌃ The huge hull of *Queen Elizabeth* towers high over the New York Police Department launch as she anchors at Quarantine in New York Harbor after her secret dash across the Atlantic. (Associated Press)

In late February preparations were made for *Queen Elizabeth* to sail. Her gloss coat of Cunard paintwork was hastily painted over with one overall coat of matt battleship grey. Shortly before noon on 3 March, assisted by just three tugs, she quietly slipped her moorings unannounced and sailed on her 15-mile voyage down the River Clyde. She was watched by less than fifty observers from the shoreline. One major factor that limited the liner's secret departure date was that there were only two spring tides in 1940 that would be high enough for *Queen Elizabeth* to leave the Clydebank shipyard. The operations department of the Abwehr, Germany's military intelligence organisation, were fully aware of this fact. Captain Konrad Patzig ordered round-the-clock surveillance of the ship via an agent who had penetrated through Ireland. Regular secret radio reports were made to the shadowy Abwehr headquarters at 76/78 Tirpitzufer in Berlin.

At the same time, Colonel Hans Pieckenbrock of the Abwehr learned that arrangements had been made to dry dock the new *Queen Elizabeth* in Southampton. This was confirmed by further reports to Berlin that the names of John Brown Shipyard employees were booked into hotels in Southampton. The Führer was advised of developments and the commander-in-chief of the Luftwaffe, Hermann Goering, sent orders for an attack force to be mobilised made up of Junkers Ju 88 and Dornier Do 17 bombers, with fighter cover from Messerschmitt Bf 109s. They were commanded by Oberstleutnant Fröhlich who had orders to sink *Queen Elizabeth* in the Solent. At the exact time *Queen Elizabeth* was due to arrive, the German bombers also appeared. To their dismay there was no sign of the new Cunard liner and the majority of the bombs were dropped on Southampton. Oberstleutnant Fröhlich and a wing of Dornier bombers circled the Solent and west Wight as far as the Needles seeking out their quarry, but *Queen Elizabeth* was nowhere to be seen. Forced to return home they released their bombs on the shipyards of Cowes and the Ryde St Johns Road railway yard, damaging an O2 tank steam locomotive.

Back on the Clyde, Captain John Townley, the master of *Queen Elizabeth*, discovered that he was to sail the world's largest passenger liner unfinished, without sufficient lifeboats and fitted with the new Swedish-designed anti-magnetic degaussing anti-mine cable. Five hours after leaving the fitting-out basin at 5.15 p.m., the new liner reached the Tail of the Bank at Greenock where she anchored off. The following day, the ship was officially handed over to Cunard in the third-class dining saloon with a few drams of Scottish whisky. This was an unprecedented event as Cunard had been forced to accept a new ship without any tests or sea trials!

The crew (most of them recruited from *Aquitania*) were mustered and they thought they were to sail south down the Irish Sea to Southampton for dry docking and fitting out. They were in for a surprise, for Captain Townley informed them that they were to make an ocean voyage. No port of destination was mentioned in his address to the crew, but the master of the *Elizabeth* had a shrewd idea where he was sailing to. A Board of Trade official arrived on board to change the ship's articles from coastal to foreign. A number of the crew requested not to make the trip owing to sickness or family reasons and were allowed to transfer ashore.

It is said that the crew remaining on board were unhappy and some even talked of going on strike. After negotiations with representatives of the National Union of Seamen, the company offered an *ex gratia* bonus payment of £30 for any inconvenience involved. The crew totalled 398, compared to the normal peacetime complement of 1,296.

The ship was under instructions to meet the King's Messenger, dispatched by the First Lord of the Admiralty, Winston Churchill, on 2 March. Inside the sealed envelope were the written orders: 'Take her to New York with all speed.' After bunkering up and making adjustments to the compass, still affixed with portions of the launch gear attached to the hull, she set sail at 11 p.m. that evening. Under way at last, she slipped through the anti-submarine boom which stretched across the Clyde between Gantocks and Cloch Lighthouse heading west. She was escorted by Avro Anson aircraft and four Royal Navy destroyers as far as the Northern Irish coast, before heading out alone into the Atlantic on a zigzag course at 27½ knots.

A calculated gamble was made that *Queen Elizabeth* could outrun any lurking U-boat wolf packs. Speed and surprise would be her best defence. She was unarmed other than pillboxes and sandbags on the bridge and stern. Radio silence was ordered, but a communication was sent to her secret call sign – GBSS – to change course and avoid a convoy as a precaution against discovery. At night the entire ship was blacked out and to aid this all windows and portholes had been painted over with anonymous matt battleship-grey paint.

Meanwhile at New York, Cunard's Percy Furness was telling the New York office manager, Robert Blake, to prepare to receive an unexpected visitor, *Queen Elizabeth*. Blake smiled and responded, 'Hmm. That means we'll have to move *Mauretania* from Pier 90 to make room for her.' On 6 March Moran Towing Company tugs quietly transferred the *Mauretania*, but this did not go unnoticed by local reporters. Rumours began to circulate Manhattan that something big was approaching New York off Nantucket heading towards the Ambrose. The suspicions were that it could be Cunard's *Queen Elizabeth*. Hastily, before first light on 7 March, a Trans World Airline aircraft was hired and piloted by the vice president of the airline. On board the small plane were reporters festooned with cameras at the ready. Yes, sure enough, it was a huge liner with two gigantic smoking funnels, but the only signs of life aboard were two miniature figures waving up from the stern. The *New York Post* called her the 'Empress Incognito'.

As she entered the Narrows at New York, news spread all around the city that a great new British super liner was entering the harbour. Work stopped, people gazed down from the skyscrapers, while others ran to welcome her from the shoreline. She paused at Quarantine and picked up the docking pilot, but by now the secret of her Atlantic dash was out.

Back in Berlin, Gertraud Traudl Humps (Adolf Hitler's private secretary from December 1942 to April 1945) reported that when the Führer learned that *Queen Elizabeth* had escaped to New York, he flew into a blistering rage with an angered white face. Frau Humps said that he looked upon *Queen Elizabeth* and *Queen Mary* as coveted prizes. He subsequently issued a reward of 250,000 Deutschmarks to any U-boat captain that could sink them, plus the Iron Cross with Oak Leaves, promotion and the glory of the Reich.

Queen Elizabeth was carefully edged into her berth at Pier 90 by tugs of the Moran fleet. Here she joined three other super liners of the Atlantic: the Cunard RMS *Queen Mary* painted in wartime grey; the French Line *Normandie* still in her peacetime livery; and the new Cunard RMS *Mauretania*. The quartet was to remain heavily guarded, for neutral New York was infested with German spies.

On 1 March *Queen Mary* was 'called up', but she did not depart New York until 21 March bound for Sydney, Australia, where she was to be converted into a trooper capable of carrying 5,000 soldiers. In the meantime, *Queen Elizabeth* remained in New York for basic fitting out, with the completion of electrical wiring and lighting. The launch gear was removed and the bottom of the ship was refurbished as it had been in the water for two years.

Towards the end of October, additional crewmen arrived in New York, having travelled via Canada. The liner's complement was brought up to 465 and *Queen Elizabeth* was replenished with fuel, water and supplies. The New York newspapers began to speculate that something was about to happen. She remained at New York until 3.30 p.m. on 13 November, when she slipped her berth. Her destination was Singapore, where she would be extensively converted into His Majesty's Troopship *Queen Elizabeth*. The route of her voyage was by way of Trinidad for refuelling, then across the South Atlantic to Simonstown naval base in South Africa. On arrival at Simonstown, the people of Cape Town assumed that the two-funnelled liner was *Mauretania*, but when her true identity became known, large crowds gathered to view her from the shoreline and at every vantage point.

The arrival of *Queen Elizabeth* in Singapore after her three-week voyage from New York was far from cordial and was viewed with suspicion by many. Sadly, during the time *Queen Mary* had been in dry dock at Singapore, some of her crew had stolen alcohol and cash, wrecking bars and bringing the good name of Cunard into disrepute. As soon as *Queen Elizabeth* entered the dry dock she was fumigated to rid her of rats which had sneaked aboard at New York. While in dry dock her troop-carrying capacity was increased, steel covers were welded over the glass-panelled engine room skylights and guns were fitted along the upper decks.

During her conversion into a troopship at Singapore, many of her crew frequented a local pub called the Pig & Whistle. The name became popular with the Cunard crews and was adopted as the name for all crew bars on Cunard ships. When she was complete, the inhabitants of Singapore were glad to be rid of the world's largest liner as she sailed for Sydney with a black-painted hull and grey superstructure. In contrast, her arrival at Sydney was greeted with cheers and enthusiasm by half the population.

After the celebrations of her arrival, *Queen Elizabeth* was towed to Cockatoo Docks for remedial repairs to rectify much of the sub-standard work carried out at Singapore. With this work complete the *Elizabeth* set sail with her sister to transport Australian and New Zealand troops to North Africa and Asia. Unfortunately, the conditions on board in these tropical climates were not satisfactory and frequent complaints were made about ventilation and cramped quarters. Between them, the two *Queens* spent a year transporting over 80,000 troops between Sydney and Port Tewfik in the Red Sea.

In August 1941 *Queen Elizabeth* had a lucky escape when a German reconnaissance plane flew over. At the time she was being steamed, blacked out, astern of the brightly illuminated and clearly marked hospital ship *Atlantis*. The German aircraft was flying so low it actually flew between the funnels of the *Elizabeth*! Had those on board the aircraft fully appreciated what they were flying over, then the whole Luftwaffe in the area would have been scrambled.

On 7 December 1941 the Japanese attacked Pearl Harbor and as a result the United States of America entered the war. This immediately changed the future plans for the Cunard *Queens* and they transferred to the Atlantic theatre where they belonged. Serious consideration was given to an Admiralty proposal to convert both Cunard *Queens* to aircraft carriers, but this idea was abandoned as their troop-carrying role was considered too important. Consequently, the two *Queens* were dry-docked in the USA where their troop-carrying capacity was increased dramatically from 5,000 to 15,000 in preparation for D-Day. It was now possible for each of the Cunard *Queens* to carry a whole American division. During these voyages the lifeboat capacity was for 8,000 souls only, but this was a factor that had to be overlooked.

On 9 November 1942 *Queen Elizabeth* was involved in an incident that to this day remains the subject of much debate. A report from Kapitän Horst Wilhelm Kessler, commander of the Type V11C U-boat *U-704*, was submitted to Admiral Karl Dönitz of the German Kriegsmarine at St Nazaire. Kessler stated that he had fired four torpedoes at a large two-funnelled steamer off the west coast of Ireland during a Force 8 gale. He maintained that the liner was travelling at speed and for some reason stopped; after a few minutes in a stationary position she

proceeded on her way. After firing the torpedoes, Kessler followed their course and a detonation was heard.

The master of *Queen Mary*, Captain Bill Bisset, who was travelling on board *Queen Elizabeth* at the time as a passenger, confirmed that there was an audible explosion near the liner, but at the time she was maintaining 31 knots.

Lord Haw-Haw announced in his 'Germany Calling' programme on 11 November 1942 that the German U boat *U-704* had torpedoed *Queen Elizabeth* and she had sunk. This was clearly a propaganda lie, but it had an unsettling effect at the time, until the 'grey ghost' arrived in New York. Staff Captain Harry Grattidge, who was working on *Queen Mary* at the time, recalled that he heard unconfirmed rumours of this incident while in New York which greatly upset him. He was never so glad to hear that the *Elizabeth* had safely reached Quarantine in New York and she was promptly toasted with a glass of red wine aboard the *Mary*.

During her wartime service as a troopship *Queen Elizabeth* had carried more than 750,000 troops and sailed more than 500,000 miles. Her captains from 1940 to 1945 were John Townley, Cyril Gordon Illingworth, Charles Ford, James Bisset and Ernest Fall.

Sir Winston Churchill said of the Cunard *Queens*:

Built for the arts of peace and to link the Old World with the New, the Queens challenged the fury of Hitlerism in the Battle of the Atlantic. At a speed never before realised in war, they carried over a million men to defend the liberties of civilisation.

To the men who contributed to the success of our operations in the years of peril, and to those who brought these great ships into existence, the world owes a debt that it will not be easy to measure.

POST-WAR, 1945–68

Queen Elizabeth sailed from her wartime base at Tail of the Bank for the final time on 7 August 1945. The crew flew a long white sheet with the words 'Thank you, Garnock' painted on it. From her mast she flew a signal: 'Thank you.' All the ships at anchor gave her a farewell salute with profuse whistles. This was a marked contrast to her secret maiden departure five years earlier. On 20 August *Queen Elizabeth* entered her home port of Southampton for the first time commanded by Captain Ernest Fall. She received a cordial reception from the mayor and curious citizens. On 27 August eight RAF Meteor jets flew over the departing *Queen Elizabeth* in formation in salute to the 15,000 men of the United States Air Force who were returning to America.

From August to early 1946 *Queen Elizabeth* was engaged in transporting American and Canadian forces back to New York and Halifax. Returning eastbound across the Atlantic, she brought home British servicemen, diplomats and officials.

An hour before departure to New York on 9 January 1946, with 12,314 Canadian troops, a black limo arrived at Ocean Dock. Out stepped the former wartime prime minister, Winston Churchill, with his wife. They were en route to Florida for a well-deserved holiday. They were greeted by Commodore Sir James Bisset with a warm handshake. It was Churchill's first visit to *Queen Elizabeth*. A second vehicle also pulled up at the quayside and a number of trunks were transferred from it to the liner, along with fishing rods, blank painting canvases, fine brushes, oil paints and eight cases of French wine and Scottish whisky for Churchill. Once settled on board, the former prime minister and his wife joined Commodore Bisset on the bridge. Mrs Churchill was presented with a posy of flowers. Winston Churchill peered through a pair of binoculars at the New Forest as the liner sailed down Southampton Water and casually lit up a huge Cuban cigar and began puffing away. This was a first, as smoking on the bridge was strictly prohibited! On this occasion not a word was said.

For the eastbound return voyage another valuable historical cargo came aboard at New York. This was the Lincoln copy of the Magna Carta, which was one of only four copies ratified by King John in 1215. In case of invasion at the outbreak of war, it had been stored at Fort Knox in the US for the duration of the war. The box containing this priceless artefact was taken by Sir Francis Evans, the British consul in New York, to the ship's strong room on D Deck. However, when they tried to carefully place the 26½ x 4½in box into the safe, it was found to be half an inch too long. Commodore Bisset therefore decided that the safest place on *Queen Elizabeth* to store the Magna Carta was under his bed in his cabin.

The return to Southampton on 6 March 1946 with 1,709 passengers marked the end of *Queen Elizabeth*'s war service. The British government decided she could now be released for a long-overdue overhaul and restoration to peacetime service. Just over 260 tons of trooping equipment had been removed from the ship at New York. On arrival at Southampton, the *Elizabeth* docked at 101 Berth where work began on stripping her out with surplus equipment being transferred to the quayside.

On 7 March, 330 workmen arrived from the John Brown Shipyard in Scotland via a special train to assist with the refit. Their presence was not altogether welcomed by the locals who had assumed that the restoration of *Queen Elizabeth* had been allocated to them. By coincidence, at 8.50 a.m. the following morning a fire was discovered by Able Seaman George Bradfield: smoke was coming out from underneath the door of the wooden structure of the isolation hospital. The fire spread rapidly through the woodwork and ignited further when stored

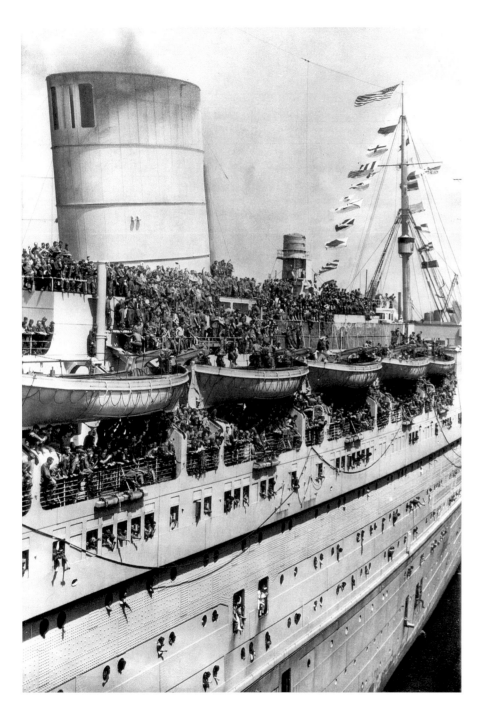

mentholated spirits and medical supplies began to burn. It took over three hours to get the blaze under control, with fire brigades from as far afield as Salisbury and Lyndhurst in attendance. At first, Mr F.T. Tarry, the chief constable of Southampton, suspected arson and deliberate sabotage. However, Professor J.B. Firth from the Home Office suggested that a workman had gone into the room, contrary to regulations, for a cigarette and the discarded, smouldering end had been the source of the fire.

After three weeks *Queen Elizabeth* sailed from Southampton to the Clyde. It was decided not to return her to the John Brown Shipyard as the navigation channels up the river were too hazardous, but to anchor her at the Tail of the Bank. A small army of John Brown workers travelled by special train to Greenock and were transferred by tender to the liner each day. Materials, tools and equipment were conveyed by lorry and tug-hauled barges to the ship. The task was simple: *Queen Elizabeth* had to be 'prepared and fitted out as new'. While at anchor Cunard insisted that steam was maintained in the boilers and the engines were at a state of constant readiness, for the ship was at an exposed anchorage and power needed to be available should the anchors drag.

Suspended from the sides of the ship and tops of the funnels on bosons' chairs, hundreds of scalers and painters chipped away at the grey wartime paint and corrosion to apply 30 tons of new paint to the exterior. The extensive air-conditioning system and electrical wiring was completely overhauled. Each of the twelve boilers was shut down, cooled and boiler tubes and fire bricks replaced. In light of the earlier fire at Southampton, a 200-strong fire patrol was deployed around the clock to prevent and detect the first signs of any fire. Items removed from the ship and placed in storage at the outbreak of war (including 21,000 pieces of furniture and 2,000 carpets) at New York, Sydney, Southampton, and at storage facilities in the New Forest, were firstly brought to a hangar at Eastleigh Airport, Southampton. Here they were identified, cleaned and restored, ready for return to the ship.

❮ Troops of the 44th Division of the US Army Corps crowd the decks, portholes and lifeboats for a first glimpse of New York on 22 July 1945. (Associated Press)

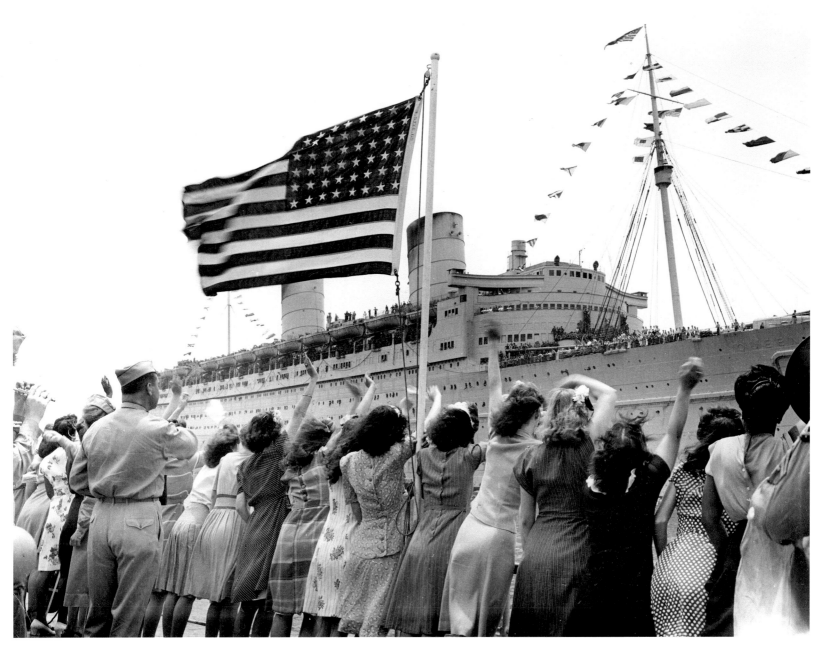

∧ *Queen Elizabeth*'s decks are packed with an entire American division, with thousands of excited troops waving and cheering, 20 February 1946. (Associated Press)

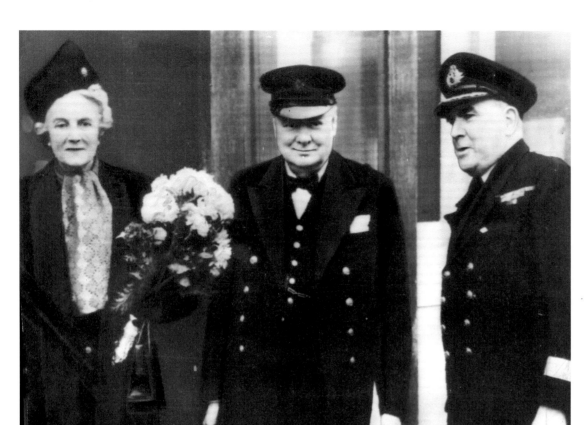

❮ Winston Churchill and his wife on the bridge of *Queen Elizabeth*, with Commodore Sir James Bisset. An hour before departure to New York on 9 January 1946, with 12,314 Canadian troops, a black limo arrived at Ocean Dock and out stepped Churchill with his wife. They were en route to Florida for a well-deserved rest. A second vehicle arrived shortly after packed with luggage, fishing rods, oil paints, blank canvases and several crates of vintage French claret and the finest Scottish whisky. (Associated Press)

Queen Elizabeth now required dry-docking for hull, rudder and propeller inspection, so she returned to Southampton on 16 June. Two trainloads of workers were sent south from John Brown's in Scotland to apply the finishing touches, including 100 female French polishers. The dock shed at 101 Berth was converted into an ad hoc canteen facility to provide 2,000 meals. Twenty temporary red telephone boxes were installed inside 101 Berth shed, a doctor and three nurses were stationed on site for first aid and medical requirements, and thirty-six extra constables were drafted in for round-the-clock security purposes. Eventually, the restoration was completed and after a complete snagging inspection Cunard signed off the JB10 Part 1 forms. Next, she sailed north to the Clyde for the Part 2 sea trials and tests.

On 8 October Her Majesty Queen Elizabeth, accompanied by their royal highnesses Princess Elizabeth and Princess Margaret, travelled to Scotland and joined the liner via the tender *Queen Mary II*. After inspecting several of the public rooms and library, the royal party arrived on the bridge at 2.50 p.m. The two princesses were given stop watches and Commodore Sir James Bisset gave the order: 'Full ahead!' The engines were brought up to full speed and the speed trials over the measured mile commenced. Under the supervision of Cunard and John Brown officials, the two princesses recorded the speed northbound at 29.71 knots and southbound at 30 knots. Under the supervision of Commodore Bisset, Her Majesty the Queen took the wheel of the liner and kept up on course. Her Majesty beamed a glowing smile, turned to Sir Percy Bates, chairman of Cunard, and said: 'I have followed the career of *Queen Elizabeth* since I launched her in 1938. I heard with great interest of her wartime voyages. It is such a wonderful record.'

The next day she returned to Southampton with 500 invited guests, including the retired Captain John Townley, her first master. Upon docking at Southampton

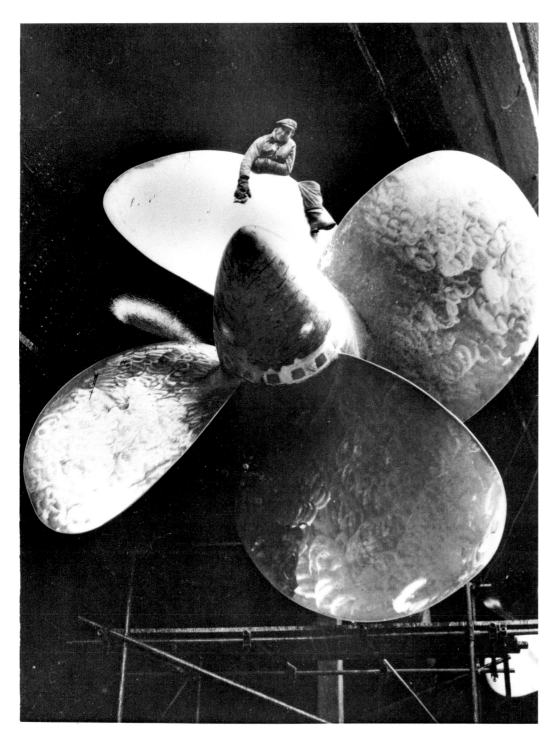

more than a thousand people visited her, followed by two special trains carrying VIP members of both Houses of Parliament. Sir Anthony Eden, MP for Leamington and Warwick, proclaimed: 'She is the ultimate in liners, the greatest ship in the world. *Queen Elizabeth* gleams like a yacht, yet is like a vast city.'

At exactly 2 p.m. on Wednesday 16 October 1946, Commodore Sir James Bisset blew the whistle of *Queen Elizabeth* three times and ordered to 'let go fore and aft'. The gleaming liner was filled to capacity with 2,288 passengers; some of them had even booked their passage before the liner had been launched eight years previously. Cheering crowds waved from every vantage point and the banks of Southampton Water and Hythe Pier were packed. On board *Queen Elizabeth*, passengers read the headline of the in-house *Ocean Times* newspaper, announcing the news that Hermann Goering had committed suicide two and a half hours before he was due to be hanged at Nuremberg.

Tragically, the day before *Queen Elizabeth* was due to sail Sir Percy Bates collapsed in his office in Liverpool. He was due to travel down to the ship at Southampton overnight to meet and greet passengers boarding the liner. Shortly before the pride of the Cunard fleet was due to sail, news came through that Sir Percy had died. His brother, Fredrick, requested Commodore Bisset not to fly the ship's flag at half-mast, saying: 'He would have wished it that way.'

❬ During the annual refit on 22 January 1954, at the King George V Graving Dock in Southampton, the propellers are inspected, cleaned and serviced. Each of the four propellers weighed 32 tons with a width of 18ft. (Associated Press)

From 1946 to 1952 the Cunard *Queens* dominated the transatlantic service. Celebrities clambered aboard at New York bound for Britain and Europe, and among the famous names were HRH the Duke and Duchess of Windsor, King Michael and Queen Helen of Romania, the Sheik of Kuwait, Prince Mohammed Faisal of Iraq, Earl Mountbatten of Burma, Bob Hope, Bing Crosby, Sir Charlie Chaplin, Laurel and Hardy, David Niven, Noël Coward, Alan Ladd, Richard Burton, Ginger Rogers, Phil Silvers and Barbara Stanwyck, to name but a few.

In April 1947 *Queen Elizabeth* ran aground on the Brambles Bank in Southampton Water, the full account of which is recalled by Commodore Geoffrey Marr and Able Seaman Joe Webb later in this book.

At 3.30 p.m. on 29 July 1959, the outward-bound *Queen Elizabeth* collided with the United States Line *American Hunter* in foggy conditions in New York Harbor. This resulted in damage to the *Elizabeth*'s starboard hawse pipe: just below the anchor was a circular 2ft-diameter hole. The American cargo ship came out of it with a rather crumpled bow. The Cunard *Queen* was towed back to her berth at Pier 90, but departure was only delayed by one day.

The most dramatic impact on *Queen Elizabeth* occurred in July 1952 when the United States Line SS *United States* captured the coveted Blue Riband for the fastest crossing of the Atlantic for both east and west voyages. As Joe Webb, who worked in the engine room of *Queen Elizabeth*, has often recalled:

⌃ John Brown builder's receipt from 1940. (Britton Collection)

❯ John Brown builder's receipt from 1942. (Britton Collection)

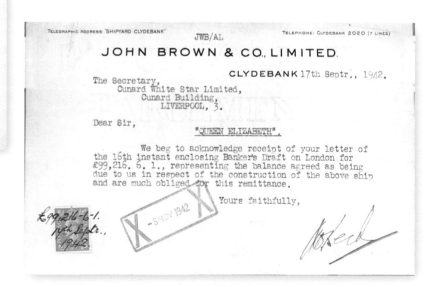

This had a devastating effect on the *Elizabeth*. We could have recaptured the Blue Riband record, as our ship had the power and capability to do so. Not all the boilers on the *Elizabeth* had all been fully engaged at one time and it could have been possible to mount a serious challenge. However, Cunard calculated that the cost of fuel would outweigh the prestige and the *United States* was given the award on a plate!

Prestigious passengers like the Duke and Duchess of Windsor, and celebrities like Bob Hope, began to transfer their custom to SS *United States*.

The threat to all transatlantic liners was to come from the air in the late 1950s and early 1960s, with the introduction of the British de Havilland Comet and Boeing 707 jet aircraft. Passengers could now cross the Atlantic in hours rather than days. The golden age for *Queen Elizabeth* and her sister *Queen Mary* was now a memory.

Strenuous efforts were made by Cunard to regain lost traffic. In 1956 *Queen Elizabeth* reappeared from her winter refit in the King George V Graving Dock at Southampton with new underwater stabilisers. This helped with the Cunard promotional campaign 'Smooth your way across the Atlantic'. Further improvements to internal facilities were made during the next refits to adapt her for the cruising market and make her more competitive. In the winter refit of 1964 a new first-class cocktail bar was built. The following £1.5 million refit in 1965 included the installation of full air conditioning in both passenger and crew accommodation to help cope with tropical climates; the provision of private showers and toilets for cabin and tourist-class cabins; and the construction of a lido area at the aft end of the promenade deck, including an outdoor heated swimming pool. These improvements were expected to provide the ship with at least an extra ten years of life.

In 1961 the decreasing revenue receipts from *Queen Elizabeth* and *Queen Mary* were of great concern to members of the Cunard board. Radical solutions were considered to address this ongoing financial state of affairs. A senior member of the Cunard Cruising Department asked Commodore Donald MacLean if *Queen Elizabeth* could be anchored off Nassau if someone thought of sending her cruising from New York. From this conversation a seed was planted. It had always been considered that the *Queens* were too big for cruising, but times were changing on the North Atlantic. Many companies were sending their liners cruising in the winter months to achieve profitability. Arguments for and against winter cruising with the *Elizabeth* continued for some months, but on 21 February 1963 she set off on the first of three booked cruises to Nassau. The cruises proved to be popular and a full cruise programme was planned out for future development.

Still, the declining economic fortunes on the North Atlantic were of great concern to the Cunard accountants and they were compounded by industrial disputes. Of these, the Seaman's Strike of 16 May–2 July 1966 sealed *Queen Elizabeth*'s fate for Cunard. The public appeared to have lost all confidence in the transatlantic service offered by the *Queens* and on several voyages the crew outnumbered the fare-paying passengers. More and more first-class passengers transferred to the reliable jet aircraft for speed and comfort. Radical economic cuts were considered and approved. First, *Queen Mary* would be placed up for sale by tender, which led to her being purchased by the City of Long Beach in California in September 1967. It was planned, however, to retain *Queen Elizabeth* and put her in partnership with a new ship, but in a letter opened on board by Captain William Law on 8 May 1967, notification of a different kind was announced by the board. In spite of her expensive refit and progress towards a profitable balance sheet, *Queen Elizabeth* was to be withdrawn from service, a year after *Queen Mary*. Furthermore, Commodore Marr would be retired early and be forced to accept a proportionate reduction in his pension!

Sir Basil Smallpiece explained the Cunard board's decision, further highlighting that £750,000 capital investment was required to allow *Queen Elizabeth* to comply with the International Maritime Commission's legislation for new standards of fire protection. This would have allowed the *Elizabeth* to sail the Atlantic for a further two years only. A decision had been made on financial grounds to withdraw the ship from service and place her up for sale by tender.

Many thought that *Queen Elizabeth* should be preserved in Southampton as a floating hotel, museum and conference centre, similar to *Queen Mary* at Long Beach. Cunard decided they could obtain a better price for the *Elizabeth* than her older sister and bids were received from September 1967 to March 1968. Interest was also expressed by at least two scrap merchants. The American evangelist Dr Billy Graham submitted a tender of £2.083 million for her to become a floating Bible College. The Japanese submitted an undisclosed tender for her to become a marine science museum in conjunction with the 1970 Tokyo World's Fair. Dr Howard Pitman made an enquiry about using the ship as an emigrant carrier to Australia.

The winning tender for £3.23 million came from a group of Philadelphian businessmen who envisaged anchoring her off Hog Island. Two months later, the purchasers ran into difficulties, the main one being that the largest passenger liner in the world could not access the Delaware River! A new site was agreed upon at Port Everglades, Fort Lauderdale, in Florida. However, with the worsening situation of the purchasers Cunard stepped in to take an 85 per cent controlling interest in the company. A new company was formed, The Elizabeth (Cunard) Corporation, and the three Philadelphian entrepreneurs, the brothers Miller, Charles Willard and Philip Klein, agreed a lease of $2 million per year.

At the end of her Cunard career, *Queen Elizabeth* had completed 896 crossings of the Atlantic carrying 2,300 passengers and had undertaken 30 cruises, steaming 3,472,672 miles. Additionally, she had served the nation in wartime conveying Allied troops safely to all parts of the globe.

The final departure from New York on 30 October 1968 was a grand occasion. The ship had been fittingly honoured with both private and official functions, culminating with a visit from Mayor John Lindsay. A band played *Auld Lang Syne* and the crowd cheered and waved her away from Pier 92. As *Queen Elizabeth* slowly sailed down the Hudson with her paying-off pennant, she was escorted by a flotilla of tugs and small pleasure craft bidding farewell to the great Queen of the Atlantic. Liners and ships saluted her with their sirens and whistles as she passed and she responded to all with three booming blasts from her whistles, which echoed across New York for the last time.

In contrast, the return to 107 Berth at Southampton at the end of Voyage 495 on 5 November turned out to be a quiet, almost dour, affair, with a distinct absence of the thousands who welcomed the final return of *Queen Mary*. It was felt by many that the city of Southampton had 'let the *Lizzie* down', especially in view of the send-off from New York. One distinguished person who had not

Ocean Times

PUBLISHED ON BOARD THE LINERS OF THE CUNARD STEAM-SHIP COMPANY LIMITED

Friday, July 24, 1959 — R.M.S. "QUEEN ELIZABETH" — **North Atlantic Edition**

SOVIET PREMIER ATTACKS AMERICA

ACCUSATION AS NIXON ARRIVES WITH MESSAGE OF FRIENDSHIP

MOSCOW.—Premier Khrushchev launched an attack on the United States as Vice-President Nixon arrived here, beaming broadly and bringing a message of friendship

Speaking in the Palace of Sport, 20 miles from where Nixon landed, the Soviet leader attacked the United States officially-backed prayer campaign for the liberation of Communist people now being held. Khrushchev said the Captive Nations Week was taking place precisely when a relaxation of international tension was noticeable.

Vice-President Nixon, unaware of Premier Khrushchev's anti-American speech, said on arrival that he came prepared to express the sincere friendship which the Americans had for Russia.

Mr. Nixon was welcomed by First Deputy Premier Koslov, and the pair spoke animatedly

CHARTER MAY BE REVIEWED

LONDON. — Foreign Affairs Under-Secretary Lord Lansdowne, speaking in the Lords debate on Foreign Affairs, said the Government believes a revision of the United Nations Charter is desirable and favours the holding of a re-

REPUBLICAN CANDIDATES

WASHINGTON.—The President has included Vice-President Nixon and Mr. Nelson Rockefeller, Governor of New York State, in a list of 10 Republicans he believes are well qualified to succeed him in the White House in 1961, it was stated here.

The President intends to remain neutral in the fight for the Republican Party's Presidential nomination next year, unless the potential winner does not support his own middle-of-the-road philosophy.

FORD EARNINGS

DEARBORN.—The Ford Motor Company has announced that its consolidated earnings for the first six months of this year were $285,900,000.

In the first six months of 1958 the company's earnings amounted to $16,100,000, but this figure was calculated under a different accounting system.

AROUND THE GLOBE

TRIVANDRUM.—Eight people were seriously injured when police used batons and tear-gas to disperse demonstrators at a local tax office.

The demonstration was part of the Opposition party's campaign to oust the Communist Kerala State Government from power.

• • •

DETROIT. — American Ford Motors chairman, Ernest Breech, said the American company is not now buying additional stock in the Ford Company of England.

Breech made the statement after a sharp rise of Ford of England shares in the London market.

• • •

LONDON.—Woodall Duckham has received an order worth nearly half a million sterling to build a British-designed town gas plant for Dunedin, New Zealand.

• • •

PARIS. — The Government has

SPORTS ITEMS AND EVENTS

Cricket

MANCHESTER.—Fourth Test, first day, close of play:
England 304 for 3 (Parkhouse 17, Pullar 131, Cowdrey 67, Smith 55 not out, Barrington 22 not out).
Bowling: Surendra Nath 2 for 81, Nadkarni 1 for 24.
India to bat.

Second day, close of play:
Glamorgan 338 for 6, Warwick 347 for 4 dec.
Kent 297 for 8 dec., Worcester 265 and 18 for 1.
Leicester 290 and 113 for 1, Essex 375 for 3 dec.
Middlesex 214, Lancashire 109 and 199 for 8.
Somerset 316 for 9 dec., Hampshire 201 and 12 for 2.
Sussex 228, Notts. 364 and 159 for 3.
Northants 359, Surrey 236 and 11 for 0.

Two-day match, second day:
Ireland 126 and 92 for 7, Yorkshire 197 and 103 for 7 dec.

• • • •

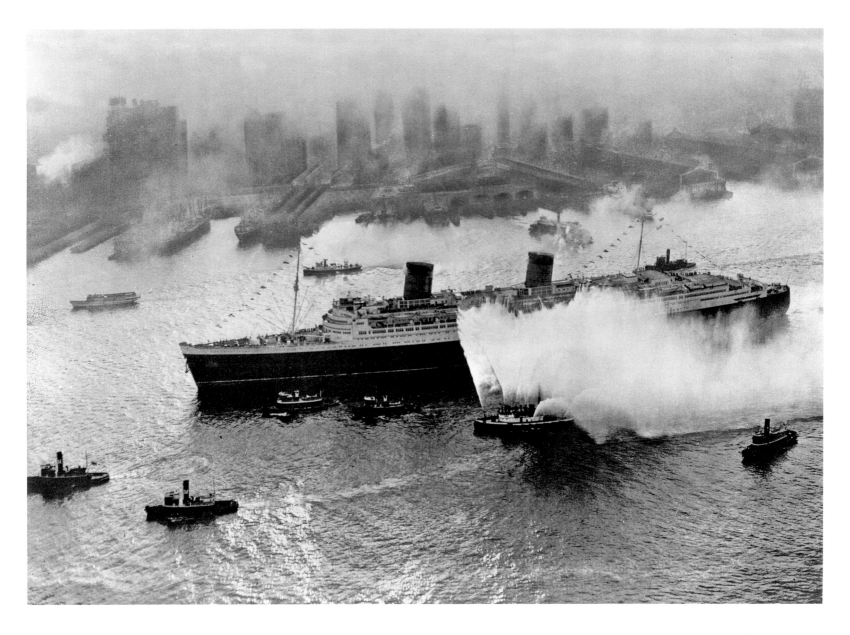

❮ *Ocean Times*, 1959. (Britton Collection)

∧ The triumphant entry of *Queen Elizabeth* into New York after her peacetime commercial maiden voyage with 2,288 passengers, 21 October 1946. A fanfare of fire boats project white plumes of spray into the air as a salute to the great *Queen*. (Associated Press)

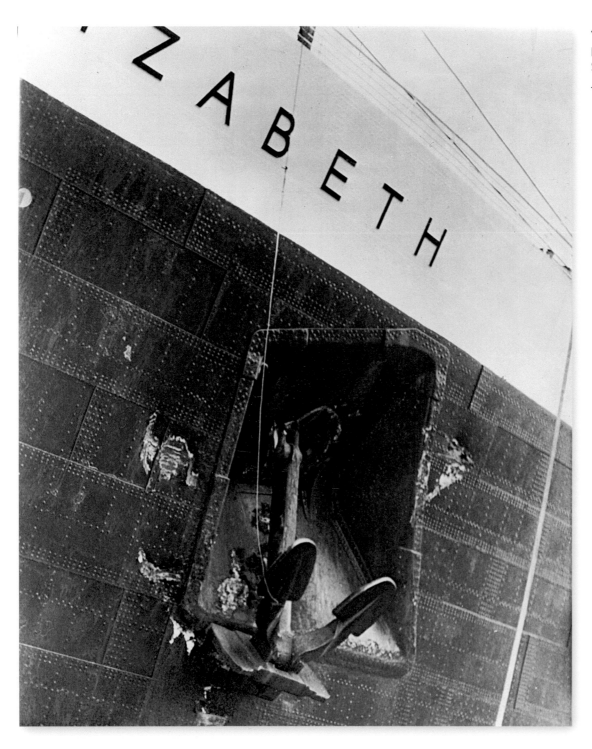

❮ A close-up view of the damaged hawse pipe sustained after the collision with SS *American Hunter* in New York Harbor in July 1959. (Associated Press)

forgotten her ship was Her Majesty Queen Elizabeth, the Queen Mother, who travelled down by train for a final visit aboard the following day. She was greeted by Commodore Marr and Captain Law and after a meal aboard she toured the ship for the last time. Her Majesty was genuinely saddened as she stepped down the gangplank for the last time.

The final departure from Southampton of *Queen Elizabeth* on 29 November 1968 was shabby and disgraceful. This super liner, the largest in the world, had provided employment to thousands from Southampton and had served the city and Cunard well. Her maiden voyage from British shores had been under a veil of secrecy and her final departure was an almost similar affair, without the pomp and circumstance that such an occasion richly and fittingly deserved for a great servant to the nation. *Queen Elizabeth* was not dressed overall and the city of Southampton did not turn out to bid her farewell as they had done for the gala final departure of *Queen Mary*. She sailed from the New Docks before dawn on a chilly, misty, autumnal November morning, almost smuggled out of the port clandestinely.

At the dockside a band played appropriate laments watched by a small crowd of barely 500 people. The great liner was facing the wrong way upstream and a 180-degree turn was required, assisted by six tugs. The tugs – *Ventnor*, *Romsey*, *Chale*, *North Isle* and *Calshot* – arrived on station to assist; the tug *Thorness* arrived too late, being delayed by the late arrival of another ship. The pilot on board *Queen Elizabeth* radioed: 'She's reluctant to come off.' The skipper of the Red Funnel tug tender *Calshot* muttered to photographer and author Colin Walker: 'She does not want to go.' The combined force of five tugs struggled and toiled to slowly turn the 83,000-ton liner in the pre-dawn darkness. As they passed Hythe Pier, it was noticed that all the tugs had been decorated with flags and the dock cranes that were manned dibbed their jibs in salute. The attempt to play down the final departure of *Queen Elizabeth* had not been totally overlooked. The emotional sound of sirens and whistles of the other ships began to cry out from the darkness of Southampton in salute. On the bridge of the *Lizzie*, Commodore Marr returned the compliment with three whistles in true maritime etiquette to each one.

PRESERVATION IN PORT EVERGLADES, FLORIDA, 1968–70

The voyage across the Atlantic with a skeleton crew was quiet and without incident. As the *Elizabeth* approached the coast of Florida and her new home on 7 December 1968, a signal was sent to 'steam slow' and cruise up and down the coastline. This was thought to be a good publicity stunt, but the reason was

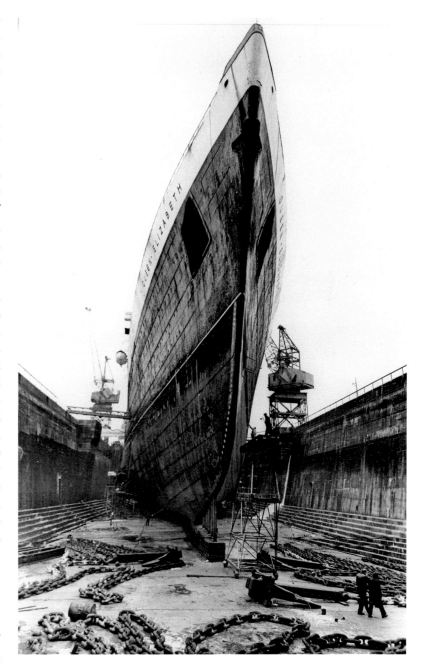

After many crossings of the Atlantic, the world's largest liner takes a rest: her bows are scraped clean in the King George V Graving Dock at Southampton, 1 September 1963. (Associated Press)

that the dredging of the channels to allow the ship to dock in Port Everglades had not been completed.

Once safely docked at temporary berth nos 24 and 25, it took almost ten weeks to convert the ship into a visitor attraction, billed as 'Queen of the Seas – one of America's foremost attractions'. The target was for *Queen Elizabeth* to be towed to a permanent berth 1 mile away once the Intracoastal Waterway had been dredged sufficiently. The ship opened to the public on 14 February 1969. Great plans were announced to develop the ship with 700 hotel rooms, two theatres and seven restaurants, plus a 5,000-person convention centre facility. Initial receipts were encouraging, but losses soon began to mount up with disappointing visitor figures. It was costing £1,250 ($3,000) per day to keep the ship at Port Everglades and the accrued losses since arrival had mounted up to $500,000. Within three months of the opening, however, Cunard announced that she was up for sale again! If a sufficiently acceptable bid had not been received by 11 June 1969, consideration would be given to break the liner up.

A bid of $8.64 million was accepted and *Queen Elizabeth* was sold to Queen Limited, a subsidiary of Utility Leasings. Soon after the transfer of ownership, a hurricane hit the coast of Florida, and to prevent the liner breaking loose from her berth, it was decided to partially scuttle her. Closed by local authorities as a fire hazard, the ship began to mount up unacceptable losses. Presented with reality by the accountants and faced with bankruptcy, the owners could see no other way forward than to place the liner up for sale by auction. At the last minute before the auction, which was due to be held at the Galt Ocean Mile Hotel, Fort Lauderdale, on 9 September 1970, a representative of the Island Navigation Company of Hong Kong placed a bid of £1.33 million ($3.2 million). After a series of telephone calls and guaranteed accreditation by the bank, the offer was accepted.

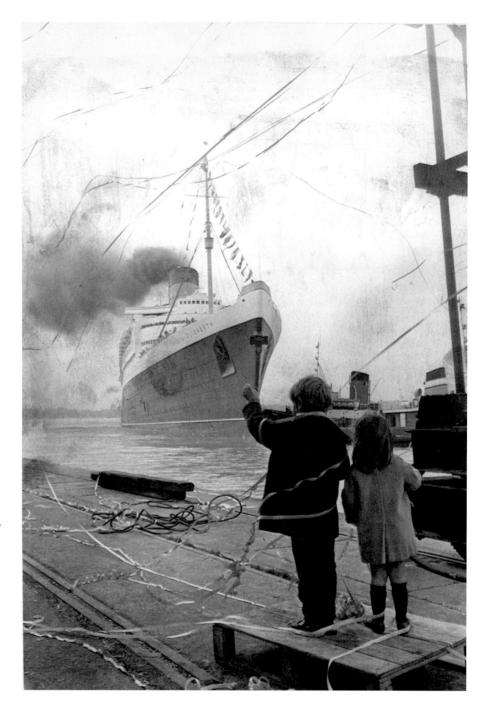

❯ Standing amid paper streamers, two little 'strangers on the shore' wave goodbye to a grand old lady, *Queen Elizabeth*, as she departs from Ocean Dock at Southampton on her final cruise to Las Palmas and Gibraltar, 9 November 1968. (Associated Press)

THE C.Y. TUNG ERA & HER DEMISE, 1970–72

The Island Navigation Company was a subsidiary of the Orient Overseas Line of Hong Kong who would be *Queen Elizabeth*'s owner and operator. The actual owner and financier was Mr C.Y. Tung, who was known to all and addressed as 'CY'. His ambitious plan was to refloat the liner and sail her to Hong Kong Harbour for a refit and conversion into a floating university chartered to Chapman College of Orange, California, carrying 1,800 students. The additional capacity on the ship would be filled with 800 cruise passengers. A Chinese crew and shipyard workers from CY's shipyards were flown out to Fort Lauderdale under the command of Captain William Hsuan. The ship was now renamed *Seawise University*, a wordplay on the new owner's name.

As *Seawise University* was much larger than anything the Chinese crew had experienced before, it was felt prudent to invite experienced advisers to assist. Accordingly, Commodore Geoffrey Marr and former chief engineer Ted Philip arrived on 18 November. They were shocked and appalled to discover the extent to which the once-proud *Queen Elizabeth* had deteriorated. Over 4,000 tons of oil-contaminated water had to be pumped out of her and after two years of neglect only six of the twelve boilers were considered in any way functional. A further dozen British advisers were flown out to assist in making the ship seaworthy. If the ship was to sail, over 600 boiler tubes would need to be replaced and fire bricks patched up. Inevitably, the target date for sailing was postponed and it was not until New Year's Eve 1970 that the first two repaired boilers were flashed up, followed by engine trials on 3 February 1971.

A date for sailing was agreed on – Wednesday 10 February – but she had only six boilers in operation, just half the power input she had arrived with, an inexperienced crew speaking a different language and a crosswind of 15 knots. The departure was going to be a precarious exercise to say the least. Moments before sailing, an urgent message was received on the bridge to say that one of the boilers had developed leaks from the previous night in the tubes. It was completely unworkable and therefore the great liner was understrength. The situation became critical when another boiler went out of action, but by this time she was moving slowly towards the 300ft entrance to Port Everglades. Commodore Marr telephoned the engine room at this point to speak to Ted Philips: 'We are committed to the channel now. See that they give her everything they can!'

This order ensured that the huge liner managed to gain just enough speed to glide through the harbour entrance. Once out into the open sea there was no reserve of power to manoeuvre. Somehow she managed to head south, but on Saturday 13 February, just after 9 a.m., a fire broke out in No. 4 boiler room. Although the fire was brought under control, a boiler was badly damaged. As the *Seawise* began to drift helplessly, Captain Hsuan requested assistance from a tug. The salvage tug *Rescue* arrived and with the assistance of a smaller tug the liner was towed to Aruba, where she anchored to make running repairs. After seventy-four days at anchor and repairs now completed, it was felt by the British advisers that the former *Queen Elizabeth* was almost back to her old self. After bunkering at Curaçao with fresh water and fuel oil, she sailed at a sedate speed of 7–11 knots as a slow boat to China. *Seawise University* eventually arrived to an early morning warm welcome in Hong Kong on Thursday 15 July, with a parade of helicopters, a fire boat display and an escort of small craft. She anchored off Tsing Yi Island near Kowloon with plans to commence work on converting her into a floating university.

Within days *Seawise University* was being stripped down and new equipment was installed to bring her up to modern safety standards. The £5 million conversion included interior redecoration to give a more oriental look and an external repaint in white with plum leaf motifs attached to her funnels. A series of cruises around the Pacific were planned with brochures printed and a marketing programme formulated. A maiden voyage from Japan was announced on 28 March.

On Sunday 9 January 1972 *Seawise University* was being made ready for her sea trials the following week. New Italian-made fire doors were to be delivered to the ship, but the frames were not the correct dimensions. There was considerable activity on the liner that morning in preparation for a celebratory cocktail party and formal lunch aboard to be hosted by C.Y. Tung's son. At 11.30 a.m. a lone yachtsman spotted flames flickering from a pile of rubbish dumped by an open door in the ship's side. Almost simultaneously at least three other fires were discovered which took hold and spread. The ship's fire-fighting team set to work but failed to control the rapidly spreading fires. Guests immediately evacuated the liner. A whole hour passed before fire-fighting tugs arrived on the scene and directed water on to the upper decks. Clouds of dense smoke engulfed the stricken liner and under the heat of the blaze parts of the superstructure began to melt and collapse. After four hours the once-great *Queen Elizabeth* was abandoned with the fire left to burn itself out. The water pumped on board by the firefighters caused the liner to list and she eventually capsized on to her side. An inquiry in July 1972 concluded that the fire had been the work of an arsonist or arsonists, but the culprits were never found. A decision was made in December 1973 to cut up the now-rusting hulk as the ship was declared unsalvageable. She hit the headlines for one final time in 1973 when her remains were used as the set location for the James Bond film *The Man with the Golden Gun*. By the time audiences around the world viewed the film, she was but a memory.

Today, the site of the wreck is buried under concrete for land reclamation on which Hong Kong's container terminal CT9 has been constructed.

R.M.S. " QUEEN ELIZABETH "

LeavingSo'ton. & Ch'bg..28th July, 19 55

Port	So'ton Tons	Ch'bg. Tons	Port	So'ton	Cher.
Cargo	162	176	First Class	444	256
Fuel	9000	8840	Cabin Class	466	190
Fresh Water			Tourist Class	505	245
Drinking	485		Total	1415	691
Reserve F.	1148		Total Passengers		2106
Domestic	3988		Crew		1277
Total Fresh	5621	5341	Total Souls		3383
Salt Water		168	Cross-Channel Passengers	14	
Stores	451	455	Mail		
Specie			Diplomatic	28	10
Mail	70	99	Ordinary	3126	967
Dunnage			Parcels		
Passengers and Baggage	166	245	Registered	346	458
Crew and Baggage	190	190	Empties		
Hold Baggage	95	140		3500	1435
Autos	4	25	Total Bags	4935	
			Specie	Nil.	
			Boxes		
				Nil.	
TOTAL	15759	15679	TOTAL	Nil.	

.............So'ton. Ch'bg........................

G.M. 5.34 ft. 5.25 Feet

Displacement :—	So'ton	Ch'bg	Draft :—	So'ton	Ch'bg.
Scale	78456	78559	Forward	39..ft.05.ins.	39...ft06..ins.
Calculated	78575	78495	Aft	39...ft.07..ins.	39...ft.07.ins
Difference	119	64	Mean	39..ft.06.ins.	39...ft06½ins.

Corrected draft

Chief Officer.

^ *Queen Elizabeth*'s journey from Southampton to Cherbourg, 1955.
(Britton Collection)

CAPTAINS OF RMS *QUEEN ELIZABETH*

Captains with registered legal command of *Queen Elizabeth* prescribed from Southampton Custom House amendments of Master C344B. (By kind permission of Commodore R. Warwick)

Name	Date of First Command
Captain John C. Townley, RNR	19 February 1940
Captain Ernest M. Fall, DSC, CBE, RD, RNR	28 August 1941
Commodore Sir James G.P. Bisset, CBE, RD, RNR	7 September 1942
Captain Cyril G. Illingworth, RD, RNR	15 January 1943
Captain Roland Spencer, RD, RNR	9 November 1943
Commodore Charles M. Ford, CBE, RD, RNR	27 April 1944
Captain John D. Snow, RD, RNR	9 September 1947
Captain John A. MacDonald, RD, RNR	24 November 1947
Commodore George Edward Cove	13 August 1948
Commodore Harry Grattidge, OBE	14 December 1948
Captain Richard B.G. Woollatt, RD, RNR	25 August 1949
Captain Harry Dixon	15 August 1950
Commodore Sir C. Ivan Thompson	14 June 1951
Commodore Robert G. Thelwell	4 September 1951
Captain Donald W. Sorrell	31 March 1953
Commodore George H.G. Morris, CBE	22 August 1956
Commodore Charles S. Williams	8 May 1957
Captain Alexander B. Fasting, RD, RNR	19 July 1957
Commodore John W. Caunce, RD, RNR	21 July 1958
Commodore Donald M. MacLean, DSC, RD, RNR	5 August 1959
Commodore Frederick G Watts, RD, RNR	14 July 1960
Captain Eric A. Divers, CBE, RD, RNR	25 July 1962
Captain Sidney A. Jones, RD, RNR	15 November 1962
Commodore Geoffrey Thrippleton Marr, DSC, RD, RNR	2 April 1964
Captain John Treasure Jones, RD, RNR	5 July 1965
Captain William E. Warwick, RD, RNR	29 October 1965
Captain George E. Smith	March 1966
Captain William J. Law, RD, RNR	1 June 1967

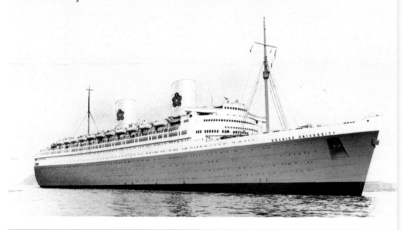

Announcing
the Maiden Voyage of SEAWISE
(formerly the R.M.S. Queen Elizabeth)
75-day Circle Pacific Cruise.

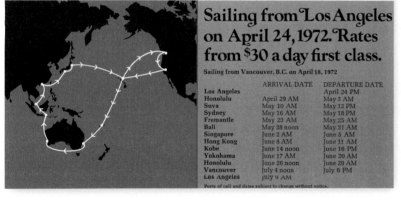

Sailing from Los Angeles on April 24, 1972. Rates from $30 a day first class.

Sailing from Vancouver, B.C. on April 18, 1972

	ARRIVAL DATE	DEPARTURE DATE
Los Angeles		April 24 PM
Honolulu	April 29 AM	May 3 AM
Suva	May 10 AM	May 12 PM
Sydney	May 16 AM	May 18 PM
Fremantle	May 23 AM	May 25 AM
Bali	May 28 noon	May 31 AM
Singapore	June 2 AM	June 5 AM
Hong Kong	June 8 AM	June 11 AM
Kobe	June 14 noon	June 16 PM
Yokohama	June 17 AM	June 20 AM
Honolulu	June 26 noon	June 29 AM
Vancouver	July 4 noon	July 6 PM
Los Angeles	July 9 AM	

Ports of call and dates subject to change without notice.

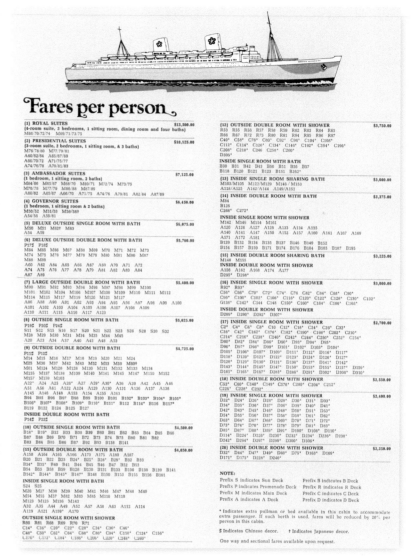

The programme for *Seawise University*'s maiden voyage which never took place. (Britton Collection)

Seawise University's fares list. (Britton Collection)

Commodore Marr was in command for the final round-trip transatlantic voyage from 20–30 October 1968 and the final cruise from Southampton to Las Palmas and Gibraltar from 8–15 November 1968. Commodore Marr was also in command for the final non-commercial Cunard Voyage from Southampton to Port Everglades from 29 November–8 December 1968 for the handover to Charles Willard Miller on behalf of the new owners. The registry of RMS *Queen Elizabeth* was cancelled at 12 p.m. on 8 December 1968: 'Certificate of Registry cancelled under Section 49 Merchant Shipping Act 1894', signed Commodore G.T. Marr and countersigned by C.W. Miller.

⌄ Valhalla! Fire boats battle to save the blazing *Seawise University* in Hong Kong Harbour. (Associated Press)

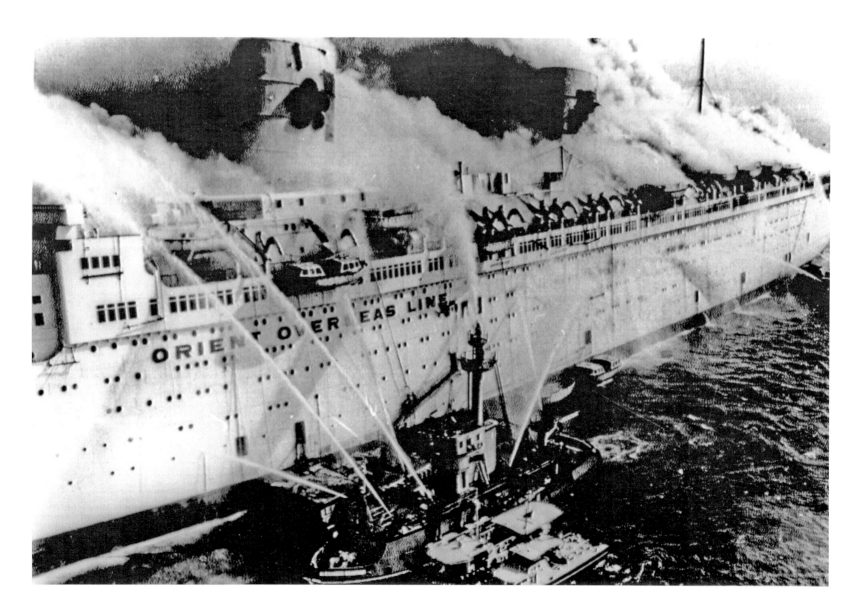

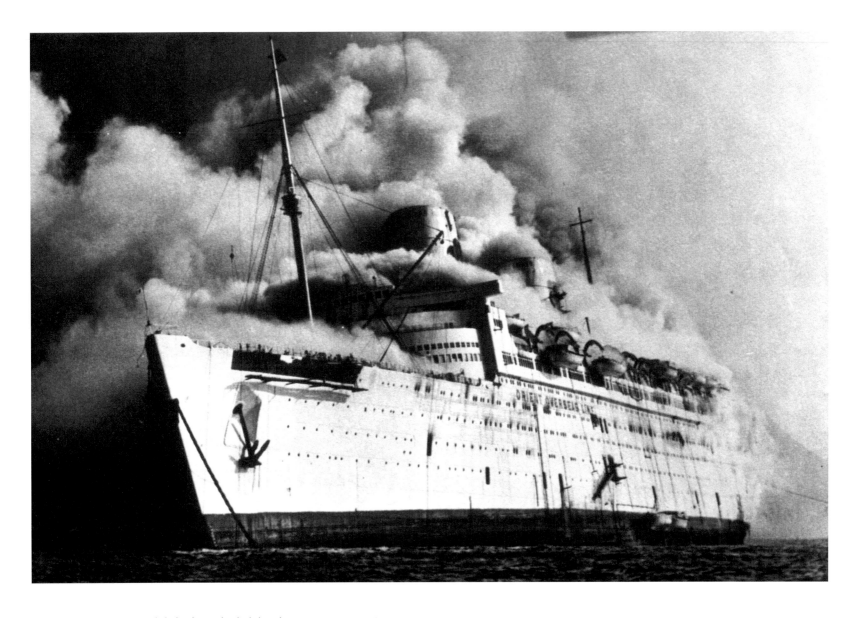

⌃ Smoke billows out and drifts from the helpless liner across Hong Kong Harbour. (World Ship Society)

MEMORIES

COMMODORE GEOFFREY THRIPPLETON MARR

I first joined the crew of *Queen Elizabeth* in February 1947 as senior first officer from my previous ship, *Mauretania*. *Queen Elizabeth* was a busy and bustling ship, which at the time, along with *Queen Mary*, was dominating the North Atlantic for passenger traffic. I quickly settled into the routines and life on this great liner and made many new friends.

The regular transatlantic routine was rudely interrupted after a few months in April 1947. After passing the Nab Tower, I decided to change into my civilian clothing ready for a quick departure from the ship as soon as we docked at Southampton. After we had passed Egypt Point at Cowes on the Isle of Wight, we were due to make a 160-degree turn around the Brambles Bank and enter the channel with the Calshot light ship right ahead. The usual practice on the Cunard *Queens* was to reduce speed on the side towards which they were turning.

Not being present on the bridge at the time, I have no idea what orders were given, but I heard shortly afterwards that Captain Ford had to step in and take a last-minute decision in command to attempt to prevent the grounding. Although I could see what was about to happen, it would have been folly to telephone the bridge to add to the confusion. From my position, right aft, it was just too late. We must have been travelling at 6–8 knots. I observed with horror as we approached closer and closer to the Brambles buoy well north of the channel. We began to shake and the four propellers churned up mud and shingle. Somebody shouted: 'We're aground!' The *Lizzie* was indeed aground there for two days.

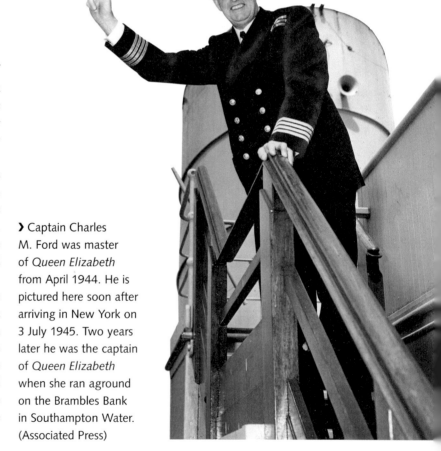

❯ Captain Charles M. Ford was master of *Queen Elizabeth* from April 1944. He is pictured here soon after arriving in New York on 3 July 1945. Two years later he was the captain of *Queen Elizabeth* when she ran aground on the Brambles Bank in Southampton Water. (Associated Press)

❮ Extract from the captain's log book at Cherbourg. (Britton Collection)

A signal was sent for assistance and the tender *Romsey* brought officials out to the liner from Southampton. An attempt was made to pull her clear, but when a towing line snapped under the strain it was thought best to wait for the high tide and summon more assistance. Tugs arrived from Portsmouth and Poole to assist the local Red Funnel and Alexandra Towing Co. tugs from Southampton. Meanwhile, water ballast was pumped off to lift her bow. At 6 a.m. the next morning, using our manila ropes, they made an attempt to free the ship. This turned out to be unsuccessful. A decision was then made to abandon pulling *Queen Elizabeth* free until the next day when there was another high tide.

On the second attempt to free *Queen Elizabeth* there were thirteen tugs attached, with a further two on each side of the ship. I was responsible for making fast the tugs assembled around the stern. Using a series of coded whistles, it was decided to waggle the great liner off the mud by first pushing her to port for fifteen minutes, then to starboard for fifteen minutes. In so doing, the movement of the ship loosened the iron grip of the mud. This strategy worked and she slid off with great cheers from everyone on board. I smiled and then laughed, but resolved never to tempt fate again by changing into civilian clothing prior to docking!

❮ Commodore W. Warwick's record book. (Britton Collection)

Promotion took me away from *Queen Elizabeth* in the summer of 1955, but I was to return as relieving captain for two voyages in early 1965. On New Year's Day 1966 I was appointed as commodore captain of the Cunard Line and took full command of *Queen Elizabeth*. At this time she was undergoing an extensive refit on the Clyde in Scotland. There was little point in travelling up all that way to join my new command as she was not due to come out of Clyde dry dock until Wednesday 9 March. I therefore set off early on the Monday morning from Southampton Central railway station to see the lay of the land on board. The major refit involved considerable disruption to the ship. I alarmingly discovered that with the addition of the new lido deck and the extension to the air-conditioning system, there were 300 uncompleted cabins on decks C and D. I also found out that the firm of builders was giving priority to another ship which was three months behind on her delivery date. The mess on board *Queen Elizabeth* was terrible, yet she was scheduled to sail from Southampton within three weeks.

Perhaps the most concerning factor was reports of considerable pilfering on Clydebank, as brass port nuts were missing and sections of vital copper pipe in the plumbing had disappeared. This would remain undetected until we were under way and the cabins were in use. After switching on a tap or pulling a sink plug out, passengers would report cabin flooding. This was embarrassing and made me extremely angry. The Clyde ship workers had let themselves down and scored a massive own goal for future Cunard contracts.

One resounding memory I have of *Queen Elizabeth* was the challenge of docking her at Pier 92 in New York during a tug strike on 1 February 1968. I would not be the first to attempt this manoeuvre as Donald Sorrell and Robert Irving had previously successfully docked the *Queens* unassisted in New York. When we stopped in the Narrows for immigration I noticed that a group of press and television crews had scrambled aboard from the pilot boat. Within a few minutes they had eagerly climbed the stairs and

❮ Commodore Warwick's Certificate of Discharge book. (Commodore R. Warwick Collection)

❮ *Queen Elizabeth*'s course book. (Britton Collection)

❯ *Queen Elizabeth*'s course book regarding her departure from Southampton Channel. (Britton Collection)

THE CUNARD STEAM-SHIP COMPANY LIMITED.

Form A. 192.

SHIP " "*Queen Elizabeth*" "

Date...........................

CHANNEL COURSES

From	Dist. Off Cables.	To	Dist. Off Cables.	Course	From	Dist. Off miles.	To	Dist. Off miles.	Course
Ocean Rock	-	N.W. Netley △	0.6	VAR.	Nab Tower	0.5	50°34'N 00°56'W.	-	180°
N.W. Netley.	0.6	Fawley Beacon.	2.2.	129°.	50°34'N 0°56'W.	-	C.H.1. Buoy.	close	208°.
Fawley Bon.	2.2	Black Jack Buoy	0.8	143°.					
Black Jack Buoy	0.8	Prince Consort.	1.5	Var.					
Prince Consort	1.5	W. Ryde Middle.	2.7	108°.					
W. Ryde Middle	2.7	S.E. Ryde middle	2.0	102°					
S.E. Ryde middle	2.0	W. Mining Ground	2.7	097°.	C.H.1. Buoy.	close	Gros du Ras ×180°	5.5	298°.
W. Mining Ground	2.7	E. Mining Ground.	3.4	113°.	Gros du Ras	5.5	Bishop Rock ×360°	5.0	269½°
E. Mining Ground	3.4	Warner Buoy	1.6	124°.					
Warner Buoy	1.6	Dean Elbow.	2.7	119°					
Dean Elbow	2.7	Nab End Buoy	4.3	107°.					
Nab End.	4.8	Nab Tower.	5.0	150°.					

_____ Chief Officer.

_____ Captain.

SIGNATURE OF WATCH KEEPING OFFICERS.

1 _____

2 _____

3 _____

asked to speak to me. They at least had the courtesy to request permission to set up their cameras on the bridge to film my attempt at docking the 83,000-ton liner without tugs, but if it all went wrong there would be a lot of egg on my face! After being given clearance, I proceeded to take *Queen Elizabeth* upstream on the Hudson River with the incoming flood tide, a couple of hours before high water. At this point it was possible to turn the ship 360 degrees, if the winds were not too strong. As luck would have it, this was a perfect day and all was calm.

The time came when I had to make the delicate manoeuvre and swing the ship around into the pier at the exact moment between high and low water. I ordered the port anchor to be dropped and it held in the mud on the bed of the Hudson. I quickly used this as a fulcrum on which to turn the ship with our engines. A small wooden rowing boat was sent out to take one of our lines ashore and this was carried up the dock to help steady the bow. Slowly and cautiously I swung the ship around almost parallel with the slip. Next, the port anchor was heaved

up and we started to move into the slip. Once the bows were halfway up the slip, I felt the ship was not likely to be affected by the tide or currents of the Hudson. Now it was a matter of moving slowly into the berth, stopping and making her fast. With the job done I turned to the camera crews with a smile and said, 'You ghouls only came here in the hope that I would give you some action pictures of the ship smashing up the pier.' The cameraman looked so innocent and surprised at my comments. He winked and replied with a broad grin, 'Commodore, whatever made you think that?'

In late February 1967 *Queen Elizabeth* set off on a long cruise to the Mediterranean, having previously taken the ship down to the West Indies on a cruise. I must admit that I had been at sea on *Queen Elizabeth* almost continuously for over seven months with just a few days at home. It was towards the end of

⌄ *Queen Elizabeth*'s New York arrival. (Britton Collection)

THE CUNARD STEAM-SHIP COMPANY LIMITED.

Form A. 192.

SHIP " *Queen Elizabeth* "

Date..............

CHANNEL COURSES

From	Dist. Off Cables	To	Dist. Off Cables	Course	From	Dist. Off Cables	To	Dist. Off Cables	Course
A.C.L.V.	10.0	Fairway Buoy	Close	308°	Castle Point	4.0	Pier 68	2.8	010°
Fairway Buoy	Close	No. 10. Buoy	1.5	297°	Pier 68	2.8	Berth Pier 90	~	Various
No. 10. Buoy	1.5	No. 14. Buoy	1.5	Various					
No. 14. Buoy	1.5	No. 19. A. Buoy	2.0	348°					
No. 19.A. Buoy	2.0	No. 22. Buoy	2.5	343°					
No. 22. Buoy	2.5	No. 24. Buoy	2.0	Var.					
No. 24. Buoy	2.0	Liberty	6.0	026°					
Liberty	6.0	Castle Pt.	4.0	010°					

_____ Chief Officer.

_____ Captain.

SIGNATURE OF WATCH KEEPING OFFICERS.

1 _____

2 _____

3 _____

∧ The boiler room log book, 1968. (Britton Collection)

Mary in the autumn of 1967 and, worse still, my ship *Queen Elizabeth* would be retired the following year, despite her expensive refit. This shocking news knocked me back into my chair and took some time to fully digest.

At the end of June I went back to work with mixed feelings. My return to the ship was greeted by the news that *Caronia*, known to many as the Green Goddess, would be withdrawn. The mood of depression and gloom was added to by the news that *Sylvania* and *Carinthia* were also to be axed by Cunard. I now began to look at *Queen Elizabeth* through different eyes and valued every minute on board. As I had a lot of leave owing to me, I would work two voyages and have the third voyage off at home.

Time stops for no man and the weeks, days and hours ticked away towards the final voyage of *Queen Elizabeth*. The time came all too soon for the last departure from New York on Wednesday 30 October 1968. It was a clear, calm and sunny autumn day and Mayor John Lindsay came aboard to make a fitting tribute speech, saying how much the city of New York valued *Queen Elizabeth* and her sister *Queen Mary*. He said that New York would never be the same without these great liners and he was right. He then presented a plaque from the American government as a citation for *Queen Elizabeth*'s war service. From the city of New York the mayor presented a bronze medallion in recognition of the close links between the ship and the city. At this point I felt a real lump in my throat and only now at the end began to fully appreciate what the ship meant to this great nation and the city of New York.

As we sailed away down the Hudson for the last time, I looked across on both sides of the ship to see the shorelines and all the piers packed with crowds of waving New Yorkers. Fire boats sprayed a fountain of water as we passed by; tugboats and sight-seeing boats followed *Queen Elizabeth* and helicopters buzzed around above us. Vessels in the piers and across at Hoboken and New Jersey sounded their whistles in salute. As the ship passed through the Narrows and under the Verrazano Bridge, I blew the ship's whistle three long times and ordered full ahead out into the Atlantic. 'Could this really be the last time at New York for *Queen Elizabeth*?' I wondered. 'If this was the send-off from the Americans, what would be the send-off from home in Southampton?' I asked myself.

I will always treasure the memory of that final transatlantic voyage. We had the comedian Frankie Howerd to entertain us. He could not stop poking fun at me and we all laughed till we hurt. There were lots of reminiscences and happy memories to recall, and on the final night we had a grand farewell ball ending up with *Auld Lang Syne*. Everyone joined in, passengers and crew, singing and dancing on the dance floor. The next morning, on 5 November, we arrived home at Southampton for the last time and berthed at 107 Berth in the New Docks; but where was the expected welcome for this sad occasion? This was a complete contrast to New York.

the Mediterranean cruise that I was beginning to feel tired and caught a flu-type cold with laryngitis, which left me without a voice for a couple of days. With fresh sea air in my lungs and regularly eating honey, I decided I was fit enough to go up to the bridge and speak to the officer of the watch. On leaving the bridge, I slipped on some cleaning detergent on the floor. I ended up on my back and after a visit to the ship's hospital I was declared to have a dislocation and a few broken bones, and I woke up to find myself in plaster. I had no choice but to hand over the command of the ship to George Smith, my staff captain.

For the next two months I wallowed in pity, but found our new home in Wiltshire most relaxing. It was during this time that Phillip Bates called in to visit me from his home in Lymington. Following pleasantries and a cup of tea to discuss my health, he dropped the bombshell: the Cunard board had decided to retire *Queen*

❮ A first-class ticket.
(Britton Collection)

❮ A cabin-class ticket.
(Britton Collection)

As soon as the last passenger had disembarked, I gave orders for a thorough clean and polish for a special visitor who had not forgotten her ship. The next day we welcomed Her Majesty Queen Elizabeth the Queen Mother to the ship for a final visit. The members of the crew drew up a guard of honour, and with the chairman and staff captain, Bill Law, we toured the ship. During her after-dinner speech, Her Majesty mentioned how she had followed the career of the ship since she launched it. After a final visit to the bridge, Her Majesty appeared to be quite sad and emotional as she stepped off the ship she had given her name to for the last time.

R.M.S. *Queen Elizabeth*

Builders : John Brown & Co. (Clydebank) Ltd., Clydebank, Scotland.

Launched : September 27th, 1938. Naming ceremony by Her Majesty Queen Elizabeth (now the Queen Mother), who was accompanied by the present Queen (then H.R.H. Princess Elizabeth) and by H.R.H. Princess Margaret.

'Secret' Maiden Voyage : Clyde–New York, March 2nd, 1940. Arrived New York, March 7th, 1940.

Service as a Troop Transport : April 1941–March 1946; carried 811,324 passengers and steamed 492,635 miles.

Trials (post-war) : October 8th, 1946, off the Isle of Arran, Firth of Clyde. H.M. Queen Elizabeth (now the Queen Mother) was on board, and she was accompanied by the present Queen (then H.R.H. Princess Elizabeth) and by H.R.H. Princess Margaret.

First Commercial Sailing : October 16th, 1946. Southampton–New York.

Length Over-all : 1,031 feet.

Breadth Moulded : 118 feet.

Depth Moulded to Promenade Deck : 92½ feet.

Height : Keel to top of superstructure, 132 feet. Keel to forward funnel, 184 feet. Keel to masthead, 234 feet.

Draught : 39 feet 0½ inch.

Gross Tonnage : 83,673.

Number of Decks : 13.

Total Passenger Capacity : 2,240.

Officers and Crew : 1,318.

Some Striking Comparisons : The *Queen Elizabeth*'s great length is more graphically evident when compared with the height of famous tall structures throughout the world, could she be placed alongside them. Thus, her bow would extend nearly 50 feet beyond the 984-foot Eiffel Tower, Paris; she would fall short of the 1,048-foot Chrysler Building in New York by less than 20 feet, and she would extend nearly three times the height of St. Paul's Cathedral, London, the cross of which is 365 feet above the ground.

Facts and Figures

^ Facts and figures of *Queen Elizabeth*. (Britton Collection)

‹ Cabin-class accommodation. (Britton Collection)

NOTICES

FIRST CLASS

ROTARIANS

Rotarians are invited to inspect the Rotary Register at the Purser's Bureau and subscribe their names. There will be an informal meeting in the Press Reception Room, Sun Deck, at 11.00 a.m. on Saturday.

SOROPTOMIST INTERNATIONAL ASSOCIATION

Soroptomists are invited to inspect the Soroptomist Register at the Purser's Bureau and subscribe their names. The Purser will be glad, providing circumstances permit, to arrange a meeting during the voyage.

LIONS INTERNATIONAL—KIWANIS ORGANISATIONS

Members of the above are kindly requested to hand their names to the Purser's Bureau. The Purser will be glad, providing circumstances permit, to arrange a meeting during the voyage.

"TRUE OR FALSE" COMPETITION

The above competition will be distributed with the morning paper today, and there will be a prize for the first correct (or nearest correct) solution handed into the Purser's Bureau by 5.00 p.m. Results will be posted on the Notice Board at 6.00 p.m.

U.S. LANDING CARDS & CUSTOMS DECLARATIONS

All passengers who embarked at Southampton are requested to present their Passports and Travel Documents at the Purser's Office today between 2.00 and 5.30 p.m. and receive Landing Cards and Customs Declaration Forms. Passengers who embarked at Cherbourg are requested to attend tomorrow.

CLOCKS

All clocks on the ship will be stopped for one hour at midnight.

R.M.S. "Queen Elizabeth" Friday, August 8, 1958

PROGRAMME OF EVENTS

a.m.

7.00—Gymnasium and Squash Racket Court open.
Swimming Pool available from 7.00 a.m. to 7.00 p.m. (weather permitting)

10.30—Recorded Concert ... Ballroom
Opera Intermezzi.
The Philharmonia Orchestra conducted by Herbert von Karajan.

11.30—11.55—Totalisator on the Ship's Run Prom. Deck Square

11.45—Passenger Boat Drill (Cherbourg Passengers) Prom. Deck
Passengers are requested to attend wearing lifebelts

11.55—Tote closes Prom. Deck Square
Winners paid shortly after noon or at the Purser's Bureau

p.m.

3.15—Melody Time Main Lounge
Ray Baines at the Organ

3.45—Music for Tea-Time Main Lounge
Marcel Torrent and His Orchestra

4.30—Film : Theatre
"Watching Points" British Movietone News
" SEA WALL "
Silvana Mangano Anthony Perkins Richard Conte

4.30—Organ Classics Main Lounge
Ray Baines at the Organ

6.00—B.B.C. News Broadcast Main Lounge

6.00—Cocktail Hour Observation Bar

6.15—"The Voice of America" News Broadcast Main Lounge

8.45—B.B.C. News Broadcast Main Lounge

9.00—" The Voice of America " News Broadcast Main Lounge

9.15—Orchestral Selections Main Lounge
Marcel Torrent and the Palm Court Orchestra

9.30—Film : Theatre
"Watching Points" British Movietone News
" SEA WALL "
Silvana Mangano Anthony Perkins Richard Conte

9.45—Bingo (Keno, Housie-Housie) Main Lounge
Interludes at the Organ

10.45—GET-TOGETHER DANCE Main Lounge
Marcel Torrent and the "Queen Elizabeth" Dance Orchestra

a.m.

12.30—Starlight Roof Club Verandah Grill
Tommy Wade and the "Queen Elizabeth" Quintet
Late Night Dancing—no cover charge

⌃ Programme of events, 1958. (Britton Collection)

The following day was an emotional time for me. The ship's company held a farewell dance and it was packed with people who had served on the ship or who had connections with her. During the evening, Staff Captain Bill Law presented me with a beautiful silver bowl, which I treasure to this day. It is inscribed: 'To Commodore G.T. Marr, DSC, RD. From the ship's company of the *Queen Elizabeth* on her final voyage. In appreciation of his unfailing thoughtfulness and his many timely arrivals.'

On 8 November we sailed on our final eight-day cruise to Las Palmas and Gibraltar. Several of my family joined us for this occasion. As we departed from Gibraltar, every Royal Navy ship in port escorted us out to sea. One by one each ship came alongside, saluted *Queen Elizabeth* and peeled away. Overhead, Sea Vixen jets screamed past, waving by dipping their wings as a tribute. This was a memorable send-off.

The return to Southampton was sad, with the crew saying their farewells – all but 193 of them who remained on board to take the empty ship to her new owners at Port Everglades. The event of our final departure from Southampton during the early misty morning of 28 November was a very disappointing disgrace. Compared with the send-offs from New York and Gibraltar it was second-rate and shameful. I have said many times that it was a British understatement with a vengeance, as though the British world of ships and ship lovers looked the other

R.M.S. " Queen Elizabeth " Monday, 23rd April, 1951

Breakfast

Grape Fruit Juice	Orange Juice	Prune Juice
Oranges	Grape Fruit	Apples

Compote of Prunes Stewed Rhubarb Compote of Figs

Rolled Oats Oatmeal Porridge

Bran Flakes Rice Krispies Weetabix Bemax

Kippered Herrings Grilled Fresh Cod, Lemon Butter

Eggs : Fried, Turned, Poached and Boiled

Omelettes (to order) : Plain and Mexican

Broiled Breakfast Bacon

Turkey Livers sauté

COLD : Pressed Beef Boiled Ham

Watercress Radishes

Griddle and Buckwheat Cakes

Maple and Golden Syrup

Breads : Whole Wheat Vienna Carmalt Hovis

Sultana White and Graham Rolls Toast

Soda Scones

Preserves Honey Marmalade

Tea Coffee Chocolate Milk Nescafé

Horlick's Malted Milk Ovaltine

Passengers on Special Diet are especially invited to make known their
requirements to the Head Waiter
Speciality foods for infants are available on request

C.C.

Cunard Line

way until she had gone! In contrast to the final departure of *Queen Mary*, few turned out to witness the final departure of *Queen Elizabeth*.

The ship appeared to be reluctant to come off at the actual time of departure. When the Red Funnel and Alexandra tugs left us, they all gave three long blasts on their whistles. Cruelly we could not reciprocate as an electronic fault had put *Queen Elizabeth*'s whistles out of action. The ships in port that dark and dismal morning saluted the ship and it was almost embarrassing to appear to ignore them. Only the Royal Navy gave *Queen Elizabeth* the send-off that she so richly deserved. As we approached the Nab Tower off the Isle of Wight, HMS *Hampshire* came alongside and her crew lined the deck, taking their hats off and raising three cheers. This was a warm tribute and I only wish that I could have responded with three blasts of our whistles. We set sail across the Atlantic like a ghost ship, deserted in almost secrecy – a reflection of her maiden voyage.

The dismal departure from Southampton left a bitter taste, but as we sailed south across the Atlantic the skeleton crew aboard tried hard to spruce the ship up. Two days before our planned arrival I received a radio telephone call from James Nall, our Cunard local representative, advising us to 'steam slow' as dredging had not been completed at Port Everglades pending our arrival. It was suggested to 'show the flag' by approaching the coast in the vicinity of Boca Raton and steam along the coastline. Slowing to about 6 knots, I could see through my binoculars that the beaches along the shoreline were packed. News of our arrival soon spread via local radio and television reports, resulting in scores of yachts and pleasure craft coming out to escort us in.

As *Queen Elizabeth* arrived at Key Biscayne too early at 4 p.m., I decided to turn and come slowly back. Reports started to come in that the ship was making an impressive sight against the setting sun. As darkness fell, the ship's floodlights were switched on as we slowly sailed north as far as Palm Beach. This caused quite a stir on the shore, judging from the reaction on the VHF. It was not until 7.30 the next morning that the local pilot came aboard and we slid quietly through the cut. Manoeuvring her up the Intracoastal Waterway and holding steady while we reversed into our berth was a challenging operation and took an hour. At 11.25 I was able to order 'finished with engines' for what we all assumed was the last time.

Not long after we docked, I was relaxing with a soothing ice-cool drink when I received a strangely worded cable from our Cunard nautical adviser in Southampton. It read: 'For Commodore Marr, in *Queen Elizabeth* on arrival. Acts 27 verse 39. Storey.' I was puzzled by this message and immediately reached for

❮ Breakfast menu, 1951. (Britton Collection)

> Programme of events for *Queen Elizabeth*'s Mediterranean cruise, 1964. (Britton Collection)

R.M.S. "Queen Elizabeth"

Mediterranean Cruise

Programme of Events

Thursday, February 27, 1964

The Commodore and members of the Ship's Company, the Cruise Director and his Staff, bid you a cordial welcome. For the many who make a Cunard Line Cruise an annual event, as well as those who have never before participated in the carefree joys of cruising, we want this Mediterranean Cruise to be a most delightful experience.

HAPPY CRUISING!

Commodore F. G. Watts, R.D.,R.N.R.

Tom Hidderley, Cruise Director

Cruise Office for Information on Shore Arrangements, Main Deck Forward, will open tomorrow morning.
Office hours at sea: 9.30 to 11.30 a.m. and 2.30 to 4.30 p.m.

☼ ☼ ☼

p.m.
5.00—R.M.S. "Queen Elizabeth" is scheduled to sail for Las Palmas (2,959 miles). Visitors are requested to leave the ship not later than 4.00 p.m.

5.45—Passenger Boat Drill Promenade Deck
The Commodore requests all passengers to attend this important muster. Lifebelts must be worn.
Your Boat Station number is posted in your cabin.

6.15—News Broadcast Forward Lounge, Midships Bar and Caribbean Club

☼

COCKTAIL TIME THIS EVENING
Your Choice of rendezvous !

The Observation Bar (Prom. Deck, Forward)
Ray Baines at the Piano — 7.00 to 8.00 p.m.

The Caribbean Club
Sidney Fawcett at the Piano — 7.00 to 8.00 p.m.

The Midships Bar

The Observation Bar (Prom. Deck, Aft.)

Dinner:
From 7.30 in both Restaurants

8.45—Ray Baines at the Organ Forward Lounge, Prom. Deck

9.00—Sidney Fawcett at the Piano Caribbean Club.
Main Deck, Aft.

9.30—Dancing Caribbean Club, Main Deck, Aft.
Wally Robb and the "Queen Elizabeth" Orchestra

9.30—Musical Selections Forward Lounge, Prom. Deck
Marcel Torrent and the "Queen Elizabeth" String Orchestra

10.00—The Paul Gene Trio and Judy Lincoln entertain
in the Midships Bar

10.30—Dancing Forward Lounge, Prom. Deck
Jimmy Watson and the "Queen Elizabeth" Orchestra

11.00 - 1.00 a.m.—Buffet Supper Verandah Grill, Sun Deck, Aft.

MOVIE PROGRAMME Theatre, Prom. Deck

At 9.45 p.m.

" From Russia With Love "
Featuring: Sean Connery and Pedro Armendariz
(Showing time: 2 hours)

(This movie will be repeated tomorrow)

CLOCKS
The clocks will be ADVANCED ONE HOUR at Midnight tonight

my Bible. Turning to the New Testament book of Acts, I looked up the scripture, which reads: 'And when it was day, they knew not the land, but they discovered a certain creek with a shore, into which they were minded, if it were possible, to thrust in the ship.'

Immediately a smile came to my face and I burst out laughing. Passing the cable and the Biblical quotation to my shipmates, the whole bridge descended into raucous laughter.

Little did I know at this point that I would rejoin the ship on her final voyage to Hong Kong as an adviser, but this was my final voyage in command of that great liner.

OFFICER BERT JACKSON

My time on *Queen Elizabeth* was very happy. I have to admit that I preferred working on her to *Queen Mary*, particularly as the staff accommodation was much better. The round voyages across the Atlantic lasted eleven days and went rapidly. On odd occasions the winter storms were threatening, but the size of the ship made her ride the waves far better than *Queen Mary* and *Mauretania*.

Heading out of New York in 1957 on *Queen Elizabeth*, I was suddenly approached by a red-faced steward. He said that a lady had been approaching the dining room when he had informed her that lunch would be served in half an hour. 'Oh,

> Programme of the day for *Queen Elizabeth*'s final voyage. (Britton Collection)

R.M.S. "Queen Elizabeth"

WELCOME ABOARD . . .
Commodore G. T. Marr, D.S.C., R.D., R.N.R., and the Ship's Company on behalf of the Cunard Line, extend to you a warm welcome We are pleased to be entirely at your service and wish to make your stay a happy and memorable experience.

PERSONAL DECLARATION FORMS . . .
Passengers are requested to complete the Declaration Forms handed to them on the Pier prior to embarkation, and return these, together with Passports, to the Purser's Office, 'R' Deck, as soon as possible.

HUDSON RIVER . . .
A map of the Hudson River, showing the Ship's course, is displayed on Promenade Deck. A commentary on points of interest will be broadcast over the Boat and Promenade Decks.

PASSENGERS DISEMBARKING CHERBOURG . . .
All passengers disembarking at Cherbourg are requested to call at the Travel Bureau on 'R' Deck to make reservations on the Boat Train, if required, and to collect Customs Declaration Forms and labels.

SPECIAL TRAIN FROM SOUTHAMPTON TO LONDON, Tuesday, November 5th
Depart Southampton 9.25 a.m. Due Waterloo (London) 10.50 a.m.
Passengers wishing to travel by this train are requested to purchase tickets and/or make their rervations as soon as possible after sailing at the Travel Bureau on 'R 'Deck.

DAILY PROGRAMME . . .
Our Shipboard Programme has been specially planned for your enjoyment. Daily, there will be a number of activities to join in or enjoy watching. In order to make the most of your trip, please study your programme carefully. Details of Religious Services will be posted on the Notice Board on 'B' Deck Square.

ATTENTION TEENS AND TWENTIES! . . .
A Get-Together will be held in The Cavern (Main Deck Aft) at 10.00 o'clock tonight.

CLOCKS . . .
The Ship's Clocks will be ADVANCED One Hour at Midnight.

FOR YOUR ENTERTAINMENT . . .

a.m.	
9.00 - 10.00—Recorded Music	Caribbean Room
10.00—Swing Along with the Stanley Poole Orchestra	Caribbean Room
11.45—R.M.S. "Queen Elizabeth" sails for Southampton via Cherbourg	
p.m.	
Luncheon will be served	**Windsor Restaurant**
Main Sitting : 12.15 p.m. Late Sitting : 1.30 p.m.	
3.45—Passenger Boat Drill	**Promenade Deck**
Your Boat Station Number is posted in your cabin. Passengers are requested to attend wearing lifebelts	
4.00—Music for Tea-Time	Caribbean Room
Stanley Poole and his Orchestra	
5.30—Top of the Pops	Caribbean Room
Lilian Eden at the Organ (relayed)	
6.30—News Broadcast	Caribbean Room
6.45—Cocktail Rendezvous with Ken Hinkin at the Piano	Club Room
6.45 - 8.45—Recorded Music	Cariboean Room
8.45—News Broadcast	Caribbean Room
10.00—Get-Together for the 'Teens and Twenties The 'Cavern', Main Deck Aft	

FINAL TRANSATLANTIC VOYAGE

Wednesday, October 30, 1968

IN THE CARIBBEAN ROOM TONIGHT . . .

9.00 p.m. — Bingo
(interludes at the Piano by Kenneth Hinkin)

followed by

G E T - T O G E T H E R D A N C E

Floor Show at 11.15 p.m. featuring

Tino Valdi

Artistes presented by arrangement with Bernard Delfont Limited
Orchestras by "Geraldo"

☆ ☆

From Midnight—"ESSENTIALLY FOR NIGHT OWLS"
Late-Night Dancing continues in the Caribbean Room
to the music of Stanley Poole and his Orchestra

FILM PROGRAMME **In the Theatre, Prom. Deck**
Showing at 10.00 and 2.30 p.m.
"High Road to Scotland" "Land of the Red Dragon"
"Shakespeare Land"
Showing at 4.30 p.m.
" NOBODY RUNS FOREVER "
Featuring Rod Taylor, Christopher Plummer and Camilla Sparv
Running time : 1 hour, 41 minutes
British Censor's Certificate "A"

C O M I N G E V E N T S

Thursday
Deck Hike Children's Get-Together Party Card Party
Table Tennis Tournament

Friday
Deck Hike
Meeting of Rotarians Meeting of Lions and Kiwanis
Shuffleboard Tournament Card Party

Saturday
Deck Hike Card Party Scrabble Tournament
Informal Talk on London Orchestral Concert
Children's Games and 'Coke' Party Fancy Head-Dress Competition

Sunday
Deck Hike Bridge Tournament Mini-Golf Tournament
Swimming Gala Children's Scavenger Hunt London Shopping Talk
Children's Fancy Costume Competition

Monday
Final Deck Hike Gymkhana

CC please see over

but I don't want to stay for lunch,' she sharply replied. The seven other people with the lady looked confused and began muttering among themselves. Upon further questioning it was discovered that this party of eight were all visitors whose farewell party had lasted too long, with perhaps too much alcohol consumed. I made an urgent telephone call to the captain on the bridge to alert him to the situation. By now, the ship was heading out towards the Narrows and into the Atlantic. The party was detained by the master at arms for further questioning and when the seriousness of the situation dawned on them that the ship had indeed sailed for Europe and they would have to pay for their tickets, there was much weeping and profuse apologies.

The captain took pity on the ladies, stopped the ship and summoned a Moran tug to hastily collect them. As the ladies transferred from the ship to the tug there were cheers of 'Bon voyage' and, still rather intoxicated and giggly, they returned to Pier 90.

There was always a constant stream of film stars and VIPs travelling on *Queen Elizabeth* in those days. In April 1961 we had Lord Louis Earl Mountbatten of Burma come aboard at New York. He was a delightful man and asked to visit the crew's Pig & Whistle bar one evening, which Commodore Donald MacLean duly arranged. There he was made welcome by the crew, some dressed in overalls having

R.M.S "Queen Elizabeth" Cunard Line

Commodore G. T. Marr,
D.S.C., R.D. (Cr. R.N.R., Rtd.)

presents his compliments and requests the

pleasure of your company at a Reception

in the Caribbean Room, Main Deck Aft,

at 6.30 p.m. on Friday, March 15th

ᐱ Invitation from Commodore Marr. (Britton Collection)

❯ New York to Nassau Cruise, 1963. (Britton Collection)

R.M.S "QUEEN ELIZABETH"

NASSAU CRUISE
1963

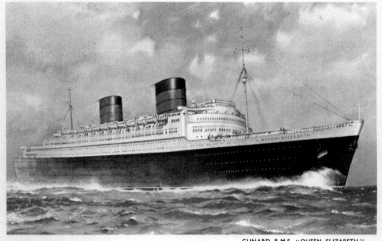

CUNARD R.M.S. "QUEEN ELIZABETH"

NEW YORK — NASSAU

February 21st — February 26th, 1963

come straight from the engine room. The earl relaxed and joined the crew in a pint of beer and a chat. The crew bar seemed to be a popular place for relaxing royals, for the Duke of Windsor paid a visit one Christmas Eve. He sat down and watched a comedian, smoked a cigar and enjoyed a pint or two while jollily singing along with the crew. The duchess was nowhere to be seen and the duke appeared to be at home with his fellow countrymen. When the time came for the duke to retire, he stood up and the crew shouted, 'Happy Christmas, Teddy', and gave three cheers. The duke smiled and was overcome with emotion.

Some VIP passengers we hardly ever saw. One was the Sheik of Kuwait and his wife. Specific halal food was always delivered to their suite and the Sheik's wife was always completely hidden with her face veiled. Other VIPs on *Queen Elizabeth* would go out of their way to present themselves in public. The charismatic American Christian evangelist Dr Billy Graham even held services on board the ship, addressing the passengers and crew. These were inspiring occasions and usually ended with Dr Graham making an appeal to those attending to commit their lives to Jesus.

Perhaps the highlight of any crossing from Southampton to New York was when we passed *Queen Mary* travelling in the opposite direction. If the weather was favourable and visibility was good, the two masters would arrange to rendezvous and pass at a safe distance. The passengers would be informed and line the rails. As the two *Queens* passed each other there would be an exchange of three whistles from each as a salute. Such occasions were always memorable and exciting.

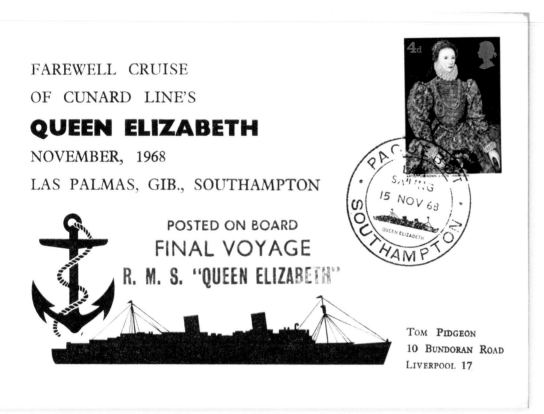

FAREWELL CRUISE
OF CUNARD LINE'S

QUEEN ELIZABETH

NOVEMBER, 1968

LAS PALMAS, GIB., SOUTHAMPTON

POSTED ON BOARD
FINAL VOYAGE
R. M. S. "QUEEN ELIZABETH"

TOM PIDGEON
10 BUNDORAN ROAD
LIVERPOOL 17

❮ A commemorative postcard of the final
cruise. (Britton Collection)

JOE WEBB

Working below decks on *Queen Elizabeth* was not a glamorous job. I joined the liner at the age of 23 years as a trimmer cleaning out the oil feed jets. This was hot, sweaty and noisy work with long hours. The twelve water tube boilers burned Bunker C fuel oil and a constant supply of steam was required at 425lb per square inch to drive the four 32-ton propellers and power the ship.

In those days after the war, life in England was tough. I was courting my wife-to-be Jean and I wanted to make a good impression, so as nylon stockings were scarce and expensive back home I decided to woo her by buying several pairs in New York. Somehow I had to smuggle this contraband back on to *Queen Elizabeth*, store it undetected and smuggle it ashore at Southampton. I sneaked the nylons on board under my coat late at night. Once on board, I headed down to the bottom of the ship where I bagged up the precious cargo. Next I fastened the bag to one of the huge shafts of *Queen Elizabeth* and smothered it over with

grease as camouflage. That bag of nylons remained unnoticed, spinning around the shaft thousands of times as it drove the propellers. On arrival in Ocean Dock at Southampton, I thought the job of delivering the precious nylons to the love of my life was almost done. I slipped on my great coat and used the nylons to pad the shoulders. Heading down the gangplank off *Queen Elizabeth*, all I could think of was the warm smile of my Jean. Suddenly, I was stopped by two men. 'Hello, what have we got here then? His Majesty's Customs.' They immediately poked my shoulders and the game was up.

On another transatlantic voyage, I was away from home on *Queen Elizabeth* for Christmas. The ship was in lockdown as we had hit the tail end of a hurricane. All portholes were closed, windows covered and doors secured. After two days out of New York and feeling pretty depressed, I decided to venture up top, get a breath of fresh air and have a smoke. I climbed the stairs, level by level, until I was on the top deck. I felt the ship going up and down, but no longer cared. Lighting my Capstan full-strength cigarette, I opened the starboard door and looked out disorientated.

My eyes were stinging and all I could see was a white mass. Where is the sea, I wondered? At that moment I looked up and saw a gigantic 90ft wave crashing down above me! I quickly retreated into the open doorway, locked it and held on. My cigarette dropped from my mouth and there was a deafening crash the other side of the door. The whole ship beneath my feet shuddered and I could hear the riveted plates on the sides of the ship squealing like a herd of pigs. Best down below, I thought. As I retreated to the depths of *Queen Elizabeth* I witnessed people being sick and utter destruction with tables, chairs, and food cannoning off the walls around the rooms and corridors. I was never so glad to walk down the gangplank at Southampton. The Customs were waiting for me again: 'Good trip, Joe?'

It was 14 April 1947 and we had sailed from New York. It had been a rough trip over with heavy seas. Speed had been reduced and we had altered course a few times, but now we could see our home port of Southampton and were due to dock at 8 p.m. The weather was a bit hazy and visibility was down to about 3 miles. I was looking forward to seeing my young wife Jean and my old man who worked for Cunard. We took on the pilot as usual, but he was not the company's requested pilot and he had not been on one of the big Cunard *Queens* before.

All was going well as we passed Ryde Pier and Cowes. We now approached the zigzag turns past the shallow Brambles sandbank. Down below in the engine room we felt the *Lizzie* swerve, judder and the order came to 'STOP ALL ENGINES!' Next came the order 'Full reverse engines!' All this had no effect. The silt and mud surrounded the ship along the length of the bridge. It sucked us in with a vice-like grip. Little did I know we would remain grounded on the Brambles for some considerable time; there was no communication allowed with the shore so I could not get a message back home to say I would be late. Our release came about through the assistance of a high tide, reducing fuel and water ballast, and by literally waddling our way free with the help of every available local tug – including Portsmouth-based naval tugs.

Sadly, I left the ship when a job came up in the docks with better pay and more favourable hours. My regular contact with *Queen Elizabeth* did not end, however, as I now looked after her needs from a shore base.

PHOTOGRAPHIC RECORD

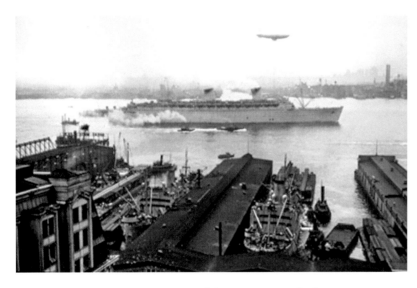

⌃ This rare colour slide was snapped from a New York skyscraper. Captain Townley is at the helm as *Queen Elizabeth* heads up the Hudson in New York, 4 March 1940. Her Cunard companions, RMS *Queen Mary* and RMS *Mauretania* are already there. (David Boone/Britton Collection)

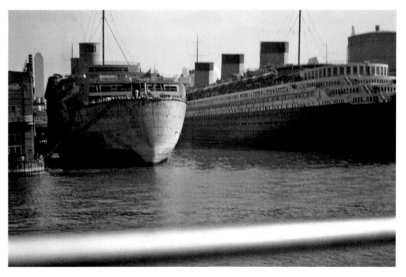

⌃ Security was strict around the liners berthed in New York in March 1940 and photographers were actively discouraged. Here, *Queen Elizabeth* is berthed next to the French Line *Normandie*. The similarities between the two superstructures are evident. (Britton Collection)

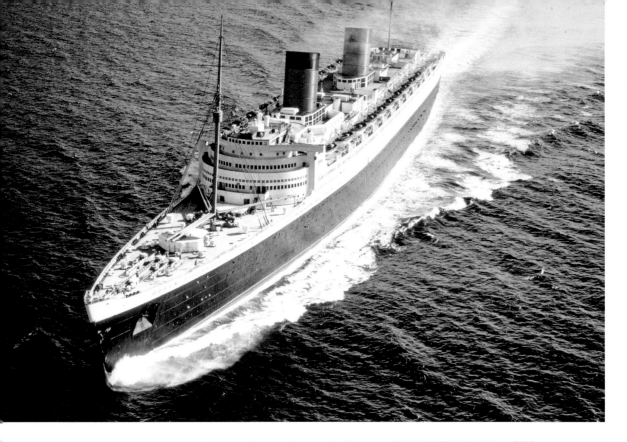

❮ The speed trials of *Queen Elizabeth* off the Isle of Arran in the Firth of Clyde, 8 October 1946. At the helm is Her Majesty Queen Elizabeth, under the direction of Commodore Sir James Bisset. (Hisashi Noma, World Ship Society of Japan)

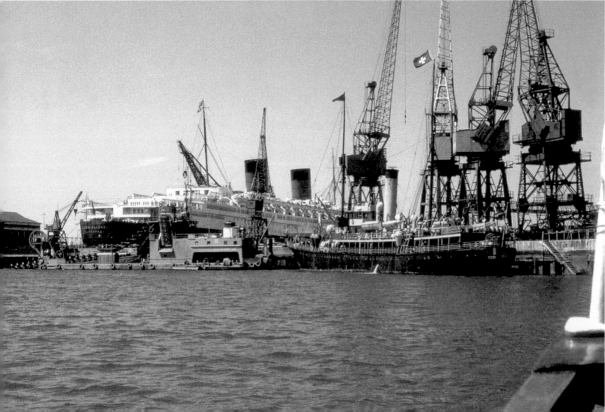

❮ The *Elizabeth* on her annual visit to the King George V Graving Dock in Southampton, which was specifically built for the two Cunard *Queen* liners by the Southern Railway in 1933. (Norman Roberts/Britton Collection)

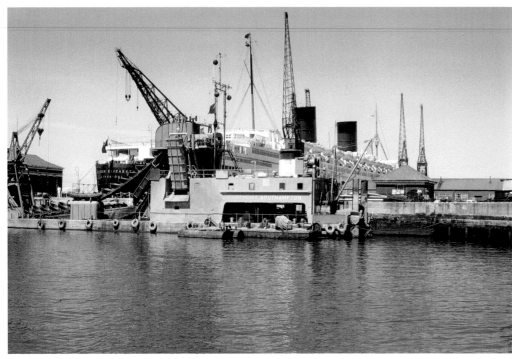

❮ *Queen Elizabeth* is photographed from a passing pleasure craft undergoing a refit in the King George V Graving Dock, 31 May 1966. (World Ship Society)

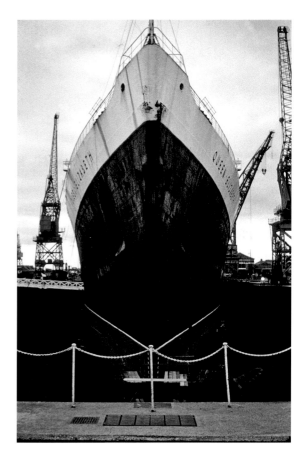
⌃ A close-up view of the impressive stem of *Queen Elizabeth* in dry dock at the King George V Graving Dock, 18 February 1961. (World Ship Society)

❮ The playground at Millbrook was a favourite place of the author and his cousins. From there it was possible to spot passing steam trains on the Waterloo–Bournemouth main line and watch work in progress on *Queen Elizabeth* in the King George V Graving Dock. (Britton Collection)

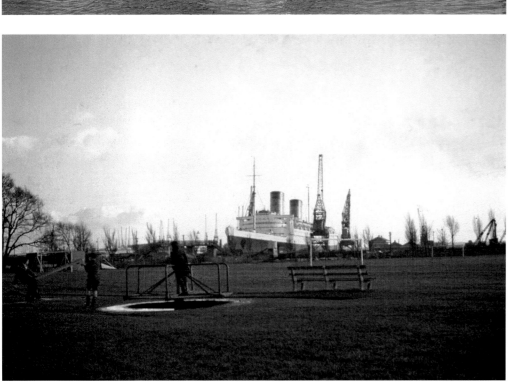

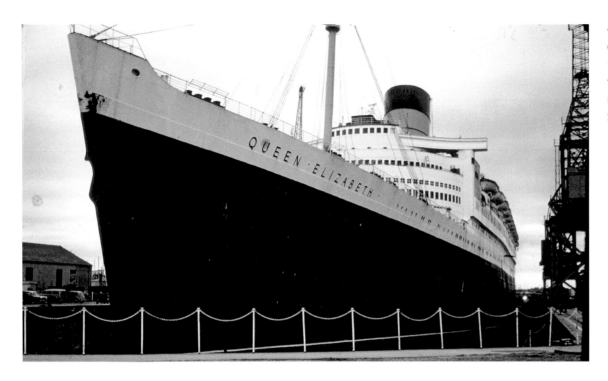

❮ *Queen Elizabeth* in dry dock at the King George V Graving Dock, 18 February 1961. The author's uncle was part of the team of painters working day and night on the ship's exterior. (World Ship Society)

❮ Photographed from the decks of SS *United States*, RMS *Queen Elizabeth* sits in the King George V Graving Dock during her 1960 refit. Immediately in front and towing the Big U are two Alexandra Towing Company tugs, *Gladstone* and *Flying Kestrel*, and Red Funnel tug *Hamtun*. (Britton Collection)

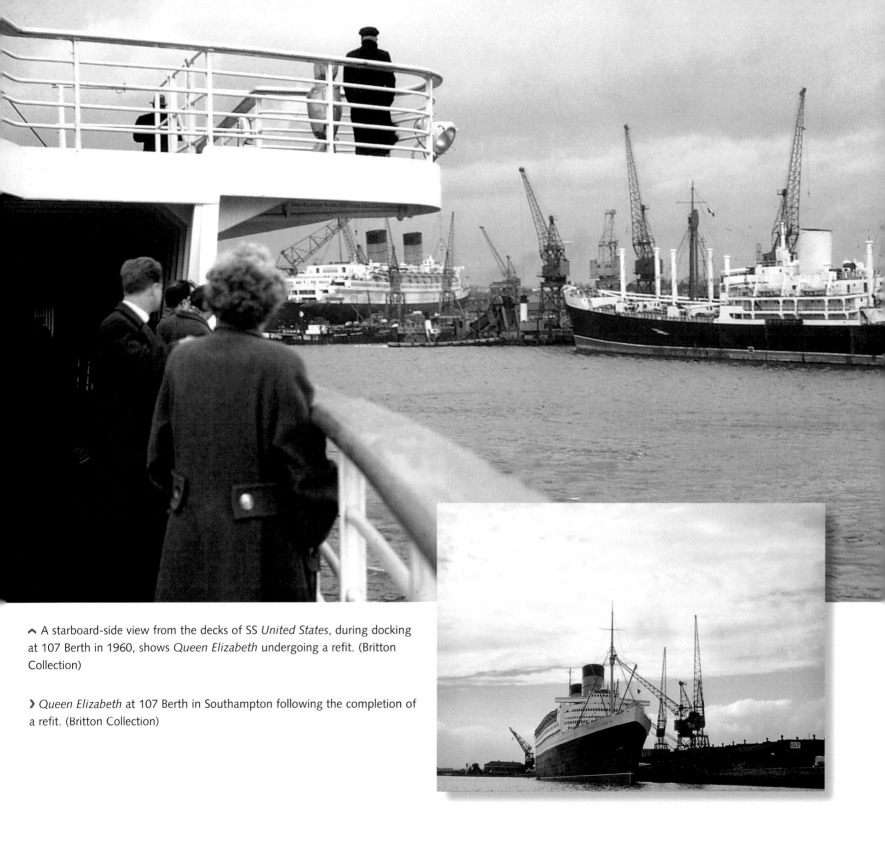

^ A starboard-side view from the decks of SS *United States*, during docking at 107 Berth in 1960, shows *Queen Elizabeth* undergoing a refit. (Britton Collection)

❯ *Queen Elizabeth* at 107 Berth in Southampton following the completion of a refit. (Britton Collection)

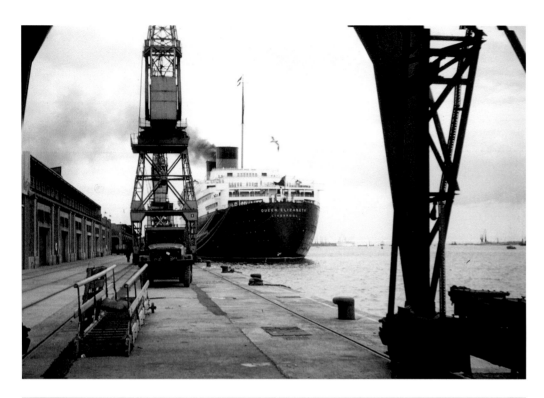

❮ Commodore Marr has ordered the steam to be gently raised in the boilers of *Queen Elizabeth* at 107 Berth ready for transfer to the Ocean Dock. A US Army lorry is on the quayside awaiting transfer on to the SS *United States*, which will return from Bremerhaven. (Britton Collection)

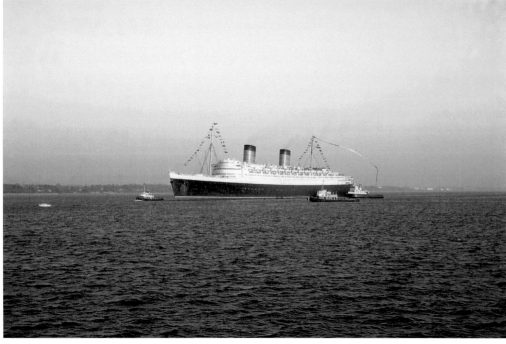

❮ RMS *Queen Elizabeth* entering port for the final time, photographed from Hythe Pier on 15 November 1968. She is complete with her paying-off pennant and is escorted by the tugs *Wellington* (Alexandra Towing), *Calshot* and *Hamtun* (Red Funnel), and *Gladstone* (Alexandra Towing). (A.E. Bennett)

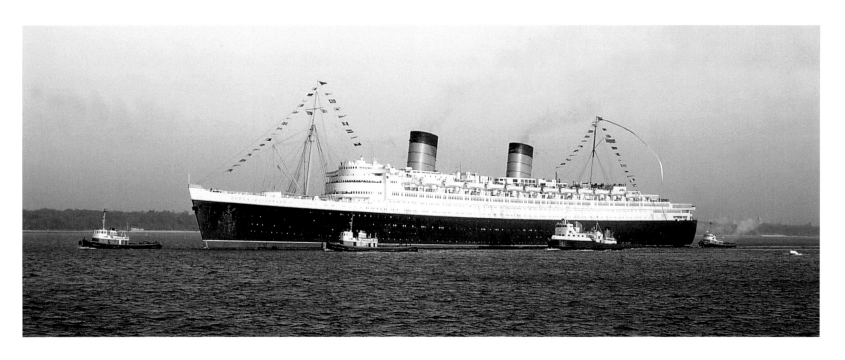

Queen Elizabeth entering port for the final time, 15 November 1968. (A.E. Bennett)

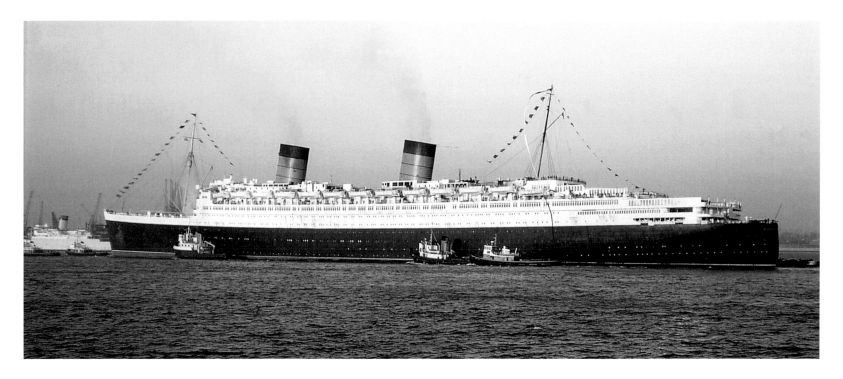

⌐ A magnificent view overlooking the famous Bar Gate towards Ocean Dock in the early 1960s, where Cunard RMS *Queen Elizabeth* and Royal Mail Line *Andes* are pictured waiting. Note the line of classic cars outside British Home Stores. (Esso/Britton Collection)

∧ It is exactly midnight in Ocean Dock on Tuesday 5 September 1967 and RMS *Queen Elizabeth* is in all her regal splendour. (Gwilym I. Davies/Britton Collection)

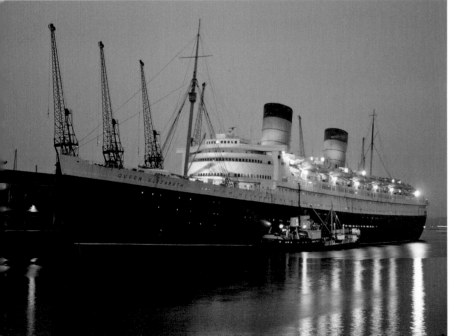

❮ The bunker tanker *Esso Lyndhurst* positions herself alongside *Queen Elizabeth* in Ocean Dock, 7 November 1968. On board she has 8,000 tons of Bunker C fuel oil which is to be transferred into the fuel tanks of the *Elizabeth* and pumped at a rate of 400 tons an hour. (George Garwood/World Ship Society)

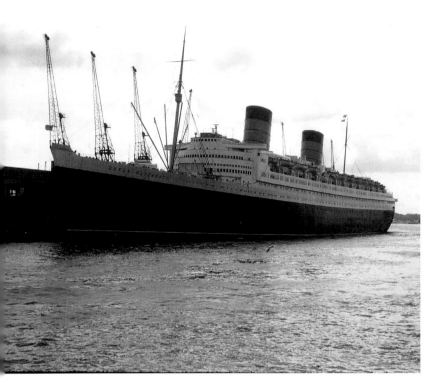

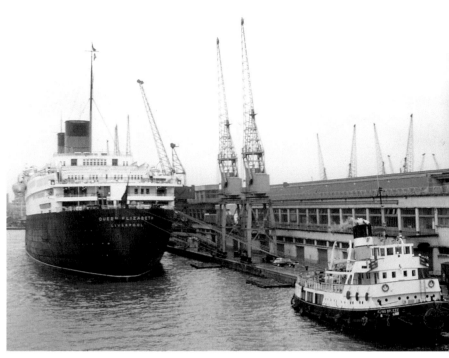

⌃ A daytime portrait of RMS *Queen Elizabeth* in Ocean Dock, 5 September 1962. (G.S. Cocks/Britton Collection)

⌐ Smoke from the funnel of the Alexandra Towing Co. tug tender *Flying Breeze* drifts across Ocean Dock. Meanwhile, the 83,673-ton *Queen Elizabeth* is firmly secured while preparations are made for her next transatlantic voyage. (Britton Collection)

❭ A row of classic cars line the quayside in Ocean Dock alongside *Queen Elizabeth*. The Blue Ensign flag signifies that the captain in command is a member of the Royal Navy Reserve; this was Captain John Treasure Jones, who had just said goodbye to his ship *Mauretania*. (G.S. Cocks/Britton Collection)

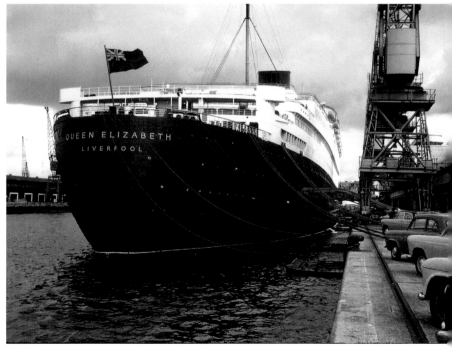

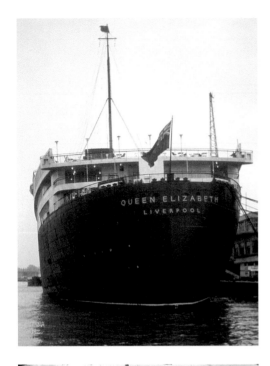

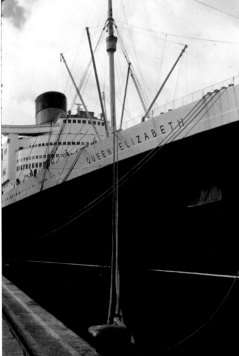

❮ A late afternoon shot of the stern of *Queen Elizabeth* and the internal lights have just been switched on. (Britton Collection)

⌄ A pair of white swans swim in front of the bow of *Queen Elizabeth*, which is tied up in Ocean Dock. (Britton Collection)

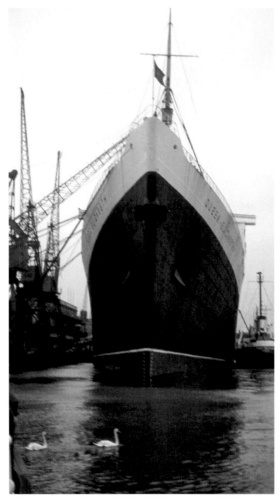

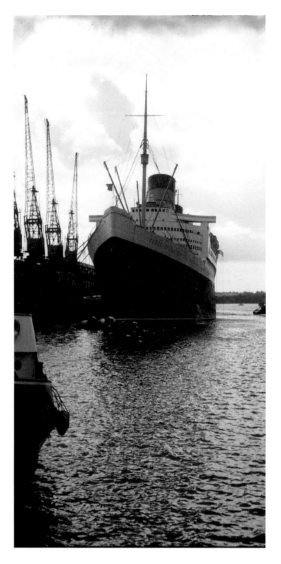

⌃ A flock of seagulls swoop down to gather some crumbs thrown from the bow of *Queen Elizabeth*. (G.S. Cocks/Britton Collection)

❮ Ropes fore. Mooring *Queen Elizabeth* in Ocean Dock was a skilled task. The new synthetic ropes were not for her and right to the end she used 9in-circumference manila fibre ropes, made at Bridport in Dorset. Each of these ropes was 120 fathoms in length, weighed 18cwt and had a breaking strain of 31½ tons. (G.S. Cocks/Britton Collection)

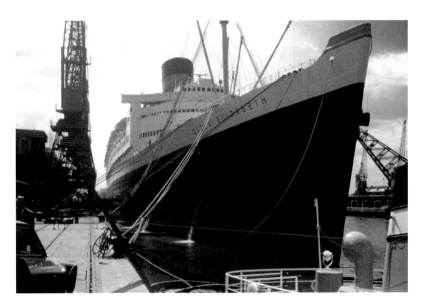

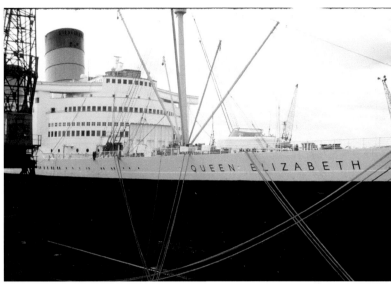

^ Ropes fore, 5 September 1962. (G.S. Cocks/Britton Collection)

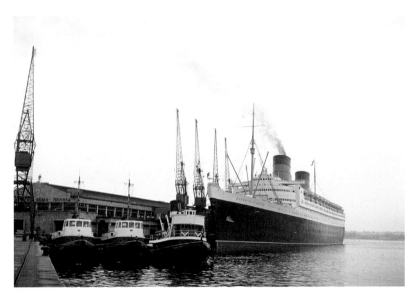

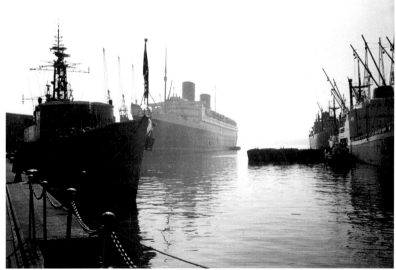

^ Alexandra Towing Company tugs *Brockenhurst*, *Romsey* and *Gladstone* are on guard duty in Ocean Dock, July 1965. (Cyril S. Perrier/Britton Collection)

^ A late afternoon atmospheric view of *Queen Elizabeth* in Ocean Dock, which appears to be full of other visiting ships. (Norman Roberts/Britton Collection)

> A pennant of *Queen Elizabeth*. (Britton Collection)

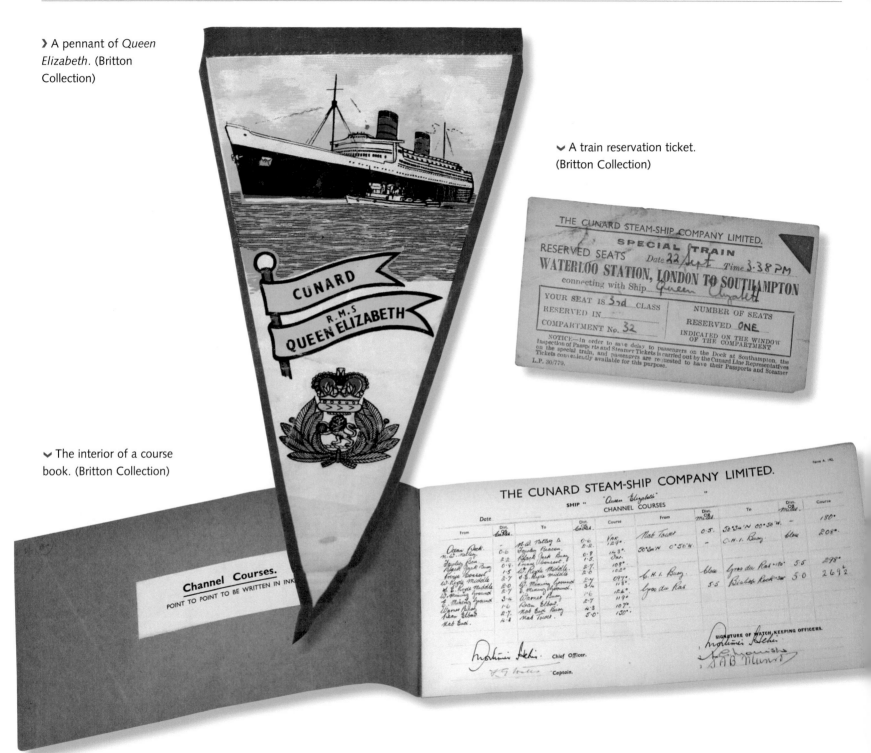

⌄ A train reservation ticket. (Britton Collection)

⌄ The interior of a course book. (Britton Collection)

^ Extract from the captain's log book, 1955. (Britton Collection)

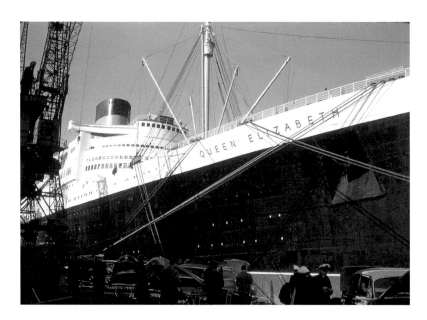

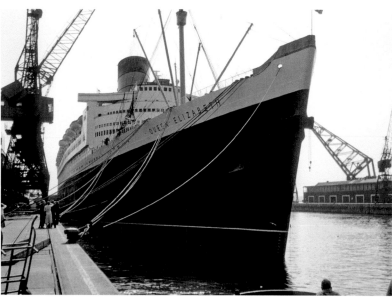

^ The deck officers of *Queen Elizabeth* and Her Majesty's Customs officers are on the quayside at Ocean Dock, 1953. They are inspecting cars prior to loading in the forward hatch. (Arthur Oakman/Britton Collection)

^ Visitors would flock to the quayside to gaze at the enormity of *Queen Elizabeth*. Family and friends of passengers were welcome to go aboard the ship and Cunard welcomed visitors to tour the great liner. (World Ship Society)

^ A Bulleid West Country Pacific steam locomotive, No. 34097 *Holsworthy*, has just arrived from Eastleigh shed and is waiting to back into Ocean Terminal. She will head the Cunarder boat train up to London Waterloo. The two funnels of *Queen Elizabeth* can be seen above her. (Alan Jarvis/John Wiltshire)

^ High above the Ocean Terminal building are the fluttering flags of the British Union Jack, United States of America Stars & Stripes and the Cunard White Star, 1953. (Arthur Oakman/Britton Collection)

^ The arrival at Ocean Terminal of Pilot Captain Jack Holt, 26 April 1968. Note the portable gangway at quayside level marked *Queen Elizabeth*, and above it is one of the telescopic ship-to-shore gangways leading directly into Ocean Terminal. (Britton Collection)

^ The Ocean Terminal building in Ocean Dock decorated for the coronation of Her Majesty the Queen, 2 June 1953. RMS *Queen Elizabeth* was the first ship to use the new terminal. In 1983 it was tragically demolished, somehow evading a preservation order. (Pursey Short/Britton Collection)

^ The dock crane has just transferred a basket of cases and passenger luggage on to the starboard-side deck of the *Elizabeth*. The forward hatch is wide open ready for loading. (Arthur Oakman/Britton Collection)

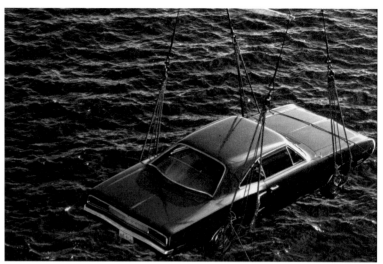

⌃ The loading of a left-hand drive Dodge automobile for conveyance to New York. (Britton Collection)

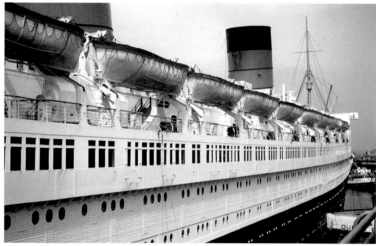

⌃ Photographer Austen Harrison has captured the fine rivet detail and rust stains of the starboard side of *Queen Elizabeth* to perfection, 17 July 1968. (Austen Harrison/World Ship Society)

❬ Essential supplies of Harp lager are piped aboard *Queen Elizabeth* from a tanker on the quayside at Ocean Dock. (Britton Collection)

❮ The mast of *Queen Elizabeth* at Ocean Dock, 1953. (Arthur Oakman/Britton Collection)

❯ 'Frapping down', as the brave crew of the *Elizabeth* climb the rigging to the mast in 1953. (Arthur Oakman/Britton Collection)

❯ The aft funnel of *Queen Elizabeth*, 5 September 1962. Note the open access door at the base. (G.S. Cocks/Britton Collection)

❯ A remarkable view of the lifeboats on the starboard side of *Queen Elizabeth*. There were twenty-six lifeboats on the *Lizzie*, each with a 145-person capacity and driven by a high-speed diesel engine. (John Goss)

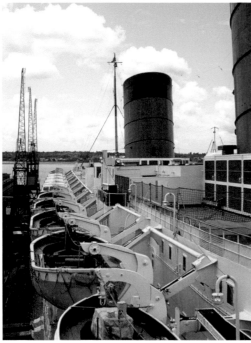

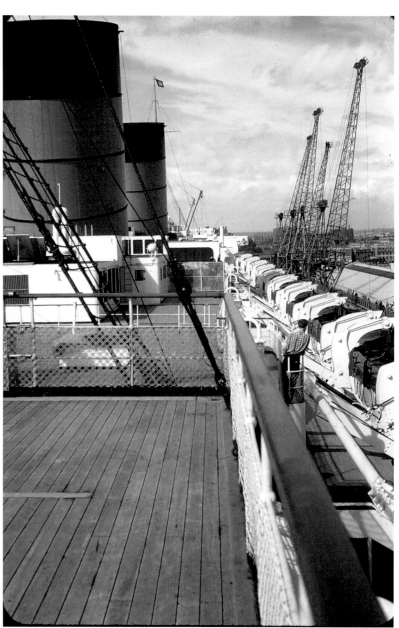

⌃ This stunning view from behind the aft funnel on the starboard side shows the lifeboats and Ocean Dock cranes to great effect. (Britton Collection)

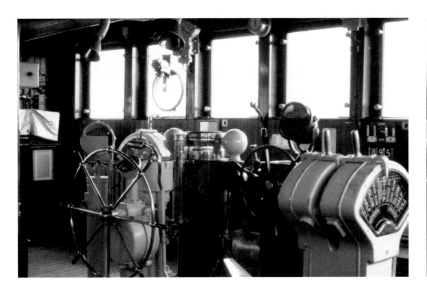

^ The bridge of the *Elizabeth* in June 1964. It was 125ft wide from wing to wing and 90ft above sea level. Vivid memories flood back to the author of the smell of polish and the rustle of charts when in the company of Commodore Marr. (W.J. Windebank/Barry Eagles Collection)

^ The bridge of *Queen Elizabeth* in June 1964. Note the four telegraphs, one for each engine. (W.J. Windebank/Barry Eagles Collection)

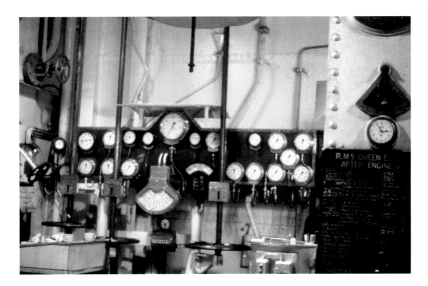

^ The after engine room control panel and starting panel of *Queen Elizabeth*, June 1964. In the words of photographer and author Colin Walker, 'This was organised confusion.' (W.J. Windebank/Barry Eagles Collection)

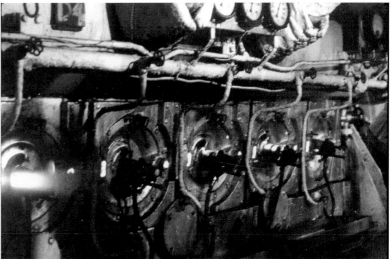

^ Some of the twelve water tube boilers of *Queen Elizabeth* in action. With a fuel supply of Bunker C oil, they maintained a steam supply to the main engines at a pressure of 425lb per square inch and at a temperature of 750°F. (Cunard/Britton Collection)

⌃ The people of Southampton hear the deafening whistle of the *Elizabeth* boom out from the aft funnel on 20 August 1964. The ship had three whistles in total: one on the aft funnel and two on the forward funnel, each weighing 1 ton. (Austen Harrison/World Ship Society)

❭ A proud captain of the *Lizzie* was Captain William E. Warwick, RD, RNR, who first commanded the liner on 29 October 1965. Commodore 'Bil' Warwick was later appointed master of her successor, the new *QE2*. (Commodore R. Warwick)

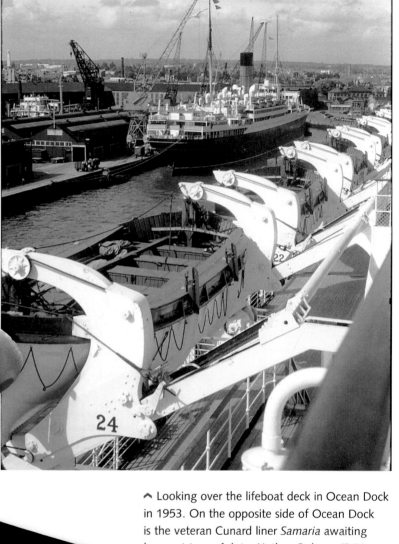

⌃ Looking over the lifeboat deck in Ocean Dock in 1953. On the opposite side of Ocean Dock is the veteran Cunard liner *Samaria* awaiting her next turn of duty. (Arthur Oakman/Britton Collection)

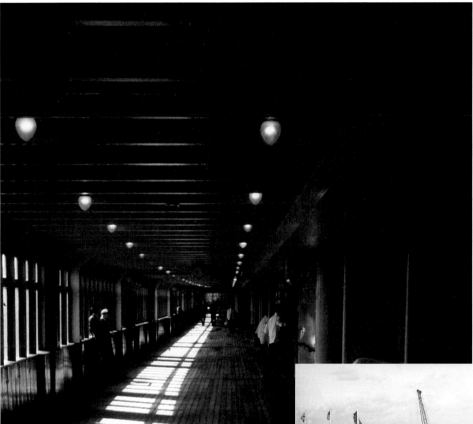

❮ Photographer Graham Cocks has captured a spectacular scene looking down the promenade deck of *Queen Elizabeth*, 5 September 1962. Note the covered deck chairs in store and the white-coated steward. (G.S. Cocks/Britton Collection)

⌄ The excited, cheering crowds of friends, family and well-wishers line the rails of the observation lounge at Ocean Terminal to watch *Queen Elizabeth* sail in 1953. (Arthur Oakman/Britton Collection)

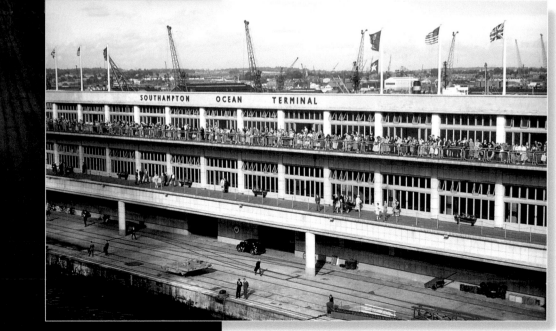

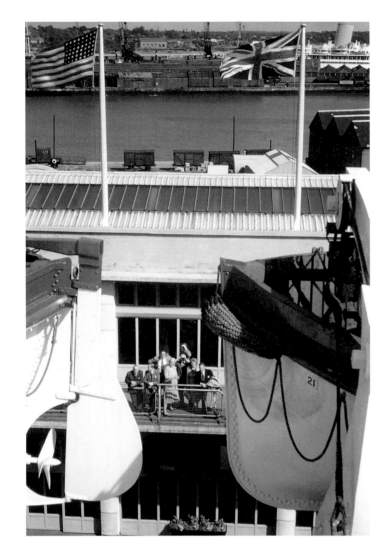

∧ Watchers from within. A view from one of the 2,000 portholes of *Queen Elizabeth*. The reflection in the glass completes the scene. (Arthur Oakman/Britton Collection)

∧ Bon voyage! A perfect portrait of the Union Jack and Stars and Stripes flags on the roof of Ocean Terminal with family members in between the lifeboats, 1953. (Arthur Oakman/Britton Collection)

❯ Masters of all they see on the starboard wing of *Queen Elizabeth*, 20 August 1964. On the right is Commodore Geoffrey Marr. In the centre is Captain Jack Holt and to his left is Senior First Officer Gossett. Just before the picture was snapped Commodore Marr is believed to have recited an amusing verse of poetry, which he so often did. (Austen Harrison/World Ship Society)

^ Commodore Geoffrey Marr, Senior First Officer Gossett and Captain Jack Holt stand on the port-side wing of *Queen Elizabeth* gazing back into Ocean Dock as the ship completes her swing manoeuvre. (Austen Harrison/World Ship Society)

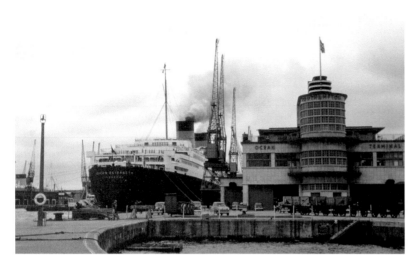

^ Smoke pours out of the funnels of *Queen Elizabeth* as she casts off from Ocean Dock and reverses out slowly. To the right of the ship is the wonderful Ocean Terminal building. (Pursey Short/Britton Collection)

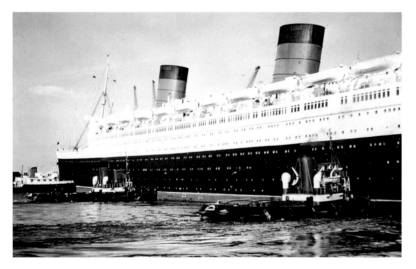

^ A trio of Red Funnel tugs tuck into the port side of *Queen Elizabeth* ready to push the 1,031ft-long liner with all their might. (Braun Brothers/Britton Collection)

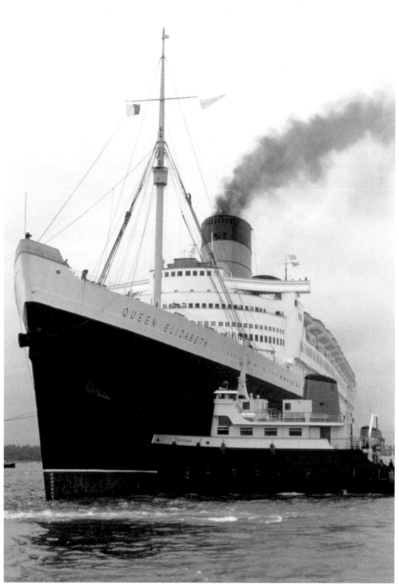

^ With the *Elizabeth* now clear of Ocean Dock, the Red Funnel tug *Gatcombe* prepares for the 'stern-swing' manoeuvre. This will bring the ship around so that her bows are pointing seawards. On the opposite starboard side of the *Elizabeth*, four more tugs will be heaving on their cables. (Pursey Short/Britton Collection)

❮ The Red Funnel tug *Clausentum* assists the *Elizabeth* with the stern-swing manoeuvre amidships on the port side. Note the tug captain on her starboard wing and above him the open shell door on the *Elizabeth*. (Braun Brothers/ Britton Collection)

❮ The Red Funnel tug *Hamtun* is in the expert hands of her master, Captain John Davidson. John is giving the tug full power, producing lots of spectacular white wash from the propellers to turn the 83,673-ton *Queen Elizabeth*. (Braun Brothers)

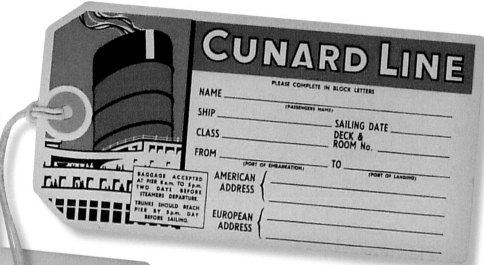

A luggage label. (Britton Collection)

Nº 67510

THIS IS A CONTRACT
ATTENTION IS DIRECTED TO THE TERMS BELOW
Not good unless
presented with stub attached.

VISITORS' CONTRACT
ADMIT ONE
R.M.S. QUEEN ELIZABETH

In consideration of your permitting the holder hereof to board the vessels and piers referred to below the holder hereof assume(s) all risk of injury or damage to person or property, and expressly agree(s) that neither The Cunard Steam-Ship Company Limited, nor any of its subsidiaries or affiliated Companies nor the Master or any member of the crew or other employees of the said Companies shall be held liable under any circumstances whatever for any personal injury or for any loss of or damage to property whether occasioned by negligence of its agents or employees or otherwise howsoever, while entering, leaving or on vessels owned or operated by the Companies or for which they act as agents, as well as piers used in connection with the berthing of such vessels. This pass is issued upon the express condition that it confers no right to enter the piers or vessels unless shown whenever required, and subject to such rules and regulations as the Government and/or the Companies may make from time to time. This pass is not transferable.

The Cunard Steam-Ship Company Limited

TO BE RETAINED

A visitor ticket.
(Britton Collection)

Nº 67511

THIS IS A CONTRACT
ATTENTION IS DIRECTED TO THE TERMS BELOW
Not good unless
presented with stub attached.

VISITORS' CONTRACT
ADMIT ONE
R.M.S. QUEEN ELIZABETH

In consideration of your permitting the holder hereof to board the vessels and piers referred to below the holder hereof assume(s) all risk of injury or damage to person or property, and expressly agree(s) that neither The Cunard Steam-Ship Company Limited, nor any of its subsidiaries or affiliated Companies nor the Master or any member of the crew or other employees of the said Companies shall be held liable under any circumstances whatever for any personal injury or for any loss of or damage to property whether occasioned by negligence of its agents or employees or otherwise howsoever, while entering, leaving or on vessels owned or operated by the Companies or for which they act as agents, as well as piers used in connection with the berthing of such vessels. This pass is issued upon the express condition that it confers no right to enter the piers or vessels unless shown whenever required, and subject to such rules and regulations as the Government and/or the Companies may make from time to time. This pass is not transferable.

The Cunard Steam-Ship Company Limited

TO BE RETAINED BY HOLDER

A key from the Elizabeth.
(Britton Collection)

^ A first-class passenger information book.
(Britton Collection)

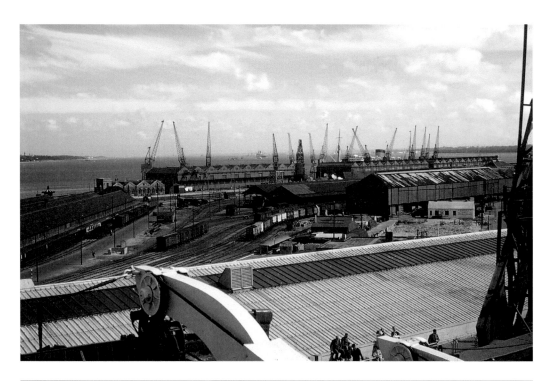

❮ Looking out from the *Elizabeth* across the complex dock next to Ocean Terminal, 1953. In the distance, heading down Southampton Water to Le Havre, is SS *United States*. (Arthur Oakman/Britton Collection)

❮ From the deck of *Queen Elizabeth* on 20 August 1964 one can see the impressive parade of ships in the New Docks at Southampton. They include SS *United States* at 107 Berth, *Oriana* at 106 Berth, *Pendennis Castle* at 104 Berth and *Windsor Castle* at 101 Berth. (Austen Harrison/World Ship Society)

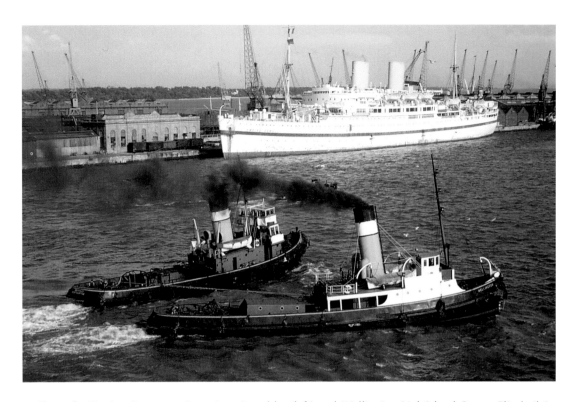

^ Alexandra Towing Company steam tugs *Brambles* (left) and *Wellington* (right) haul *Queen Elizabeth* in her stern-swing manoeuvre past the troopship *Empire Orwell*. (Arthur Oakman/Britton Collection)

^ With the Red Funnel tug tender *Calshot* ahead, the *Elizabeth* gingerly coasts down Southampton Water. In this 1953 shot we are looking forward over the bow as deckhands are busy at work carefully rolling up the ropes. (Arthur Oakman/Britton Collection)

❮ The *Elizabeth* coasts down Southampton Water, 1953. (Arthur Oakman/Britton Collection)

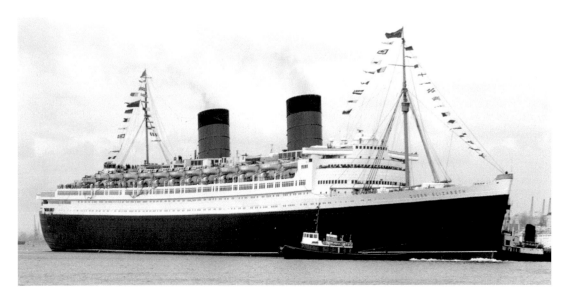

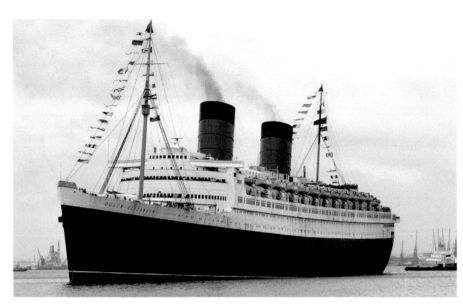

❮ The *Elizabeth* coasts down Southampton Water, 1953. (Arthur Oakman/Britton Collection)

❮ *Queen Elizabeth* heads solo down Southampton Water towards the Isle of Wight, 27 July 1967. (Austen Harrison/World Ship Society)

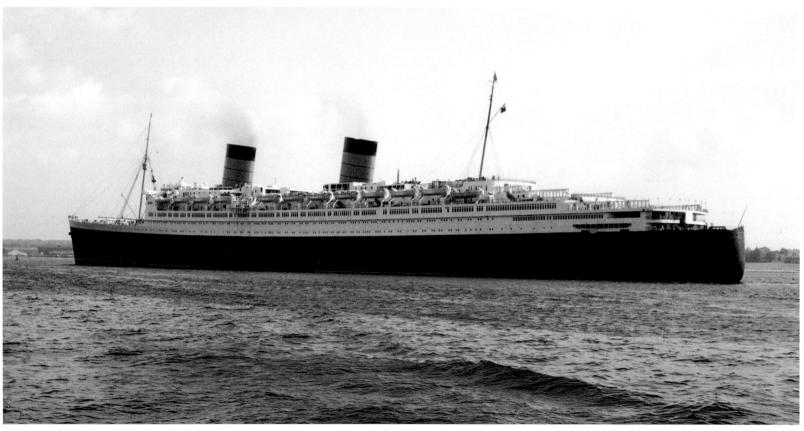

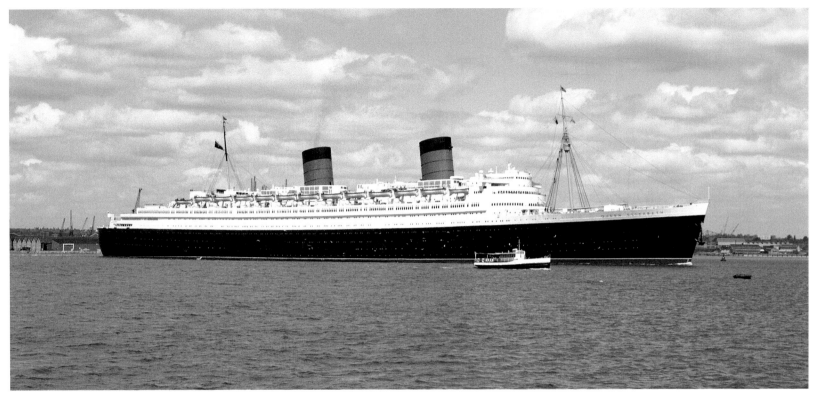

⌃ *Queen Elizabeth* is escorted by a Blue Funnel Line pleasure craft packed with sightseers down Southampton Water past Hythe, May 1964. (Marc Piche)

❯ A moment of magic as tourists pay homage to the *Elizabeth* as she sails past Cowes. There were Island photographers who knew every nook and cranny from where to photograph passing liners and David Peters was one such person. (David Peters)

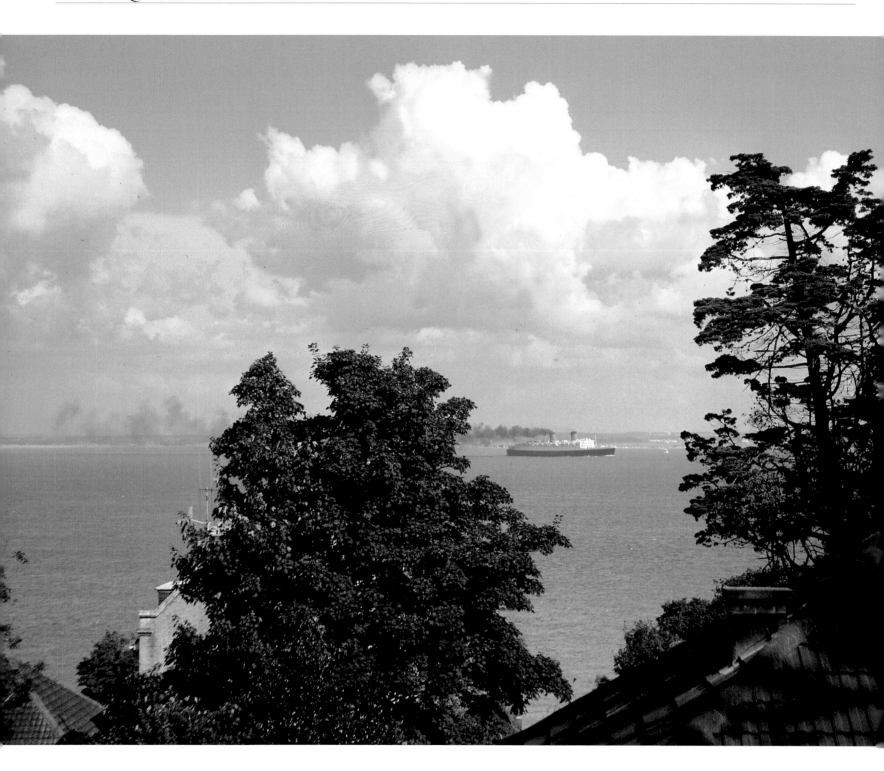

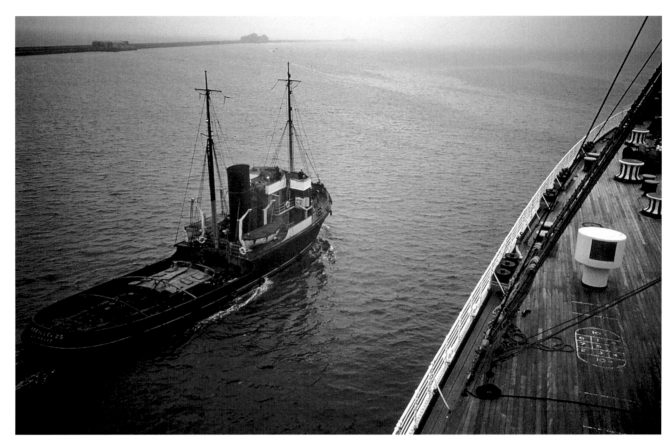

❮ Through the treetops at Cowes one can see a thick black smoke plume from the aft funnel, signifying an increase in speed. (David Peters)

⌃ The Le Havre-registered tug *Abeille W25* escorts the *Elizabeth* into Cherbourg Harbour on the port-side forward bow. The French word *Abeille* means 'bee', which was appropriate for this busy tug. (Arthur Oakman/Britton Collection)

❯ *Queen Elizabeth* anchors off Grande Rade on a windy day awaiting the Cherbourg tender to transfer passengers wishing to alight in France, 1953. Ahead is the tug tender *Igenieur Minard*, with its Cunard White Star Line canvas-covered gangway. (Arthur Oakman/Britton Collection)

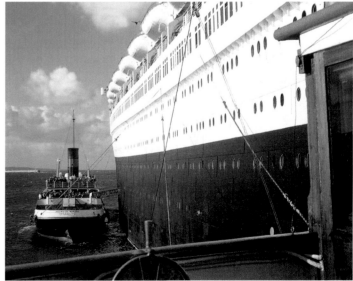

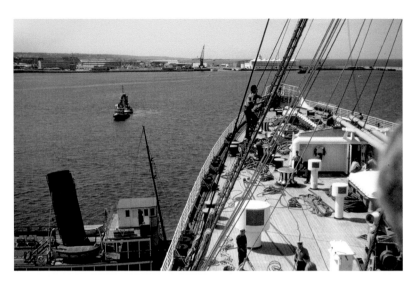

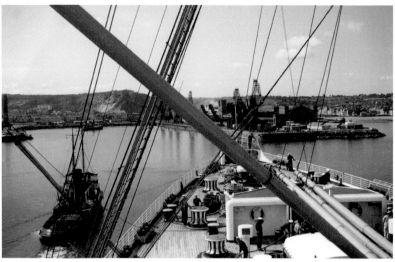

⌃ Approaching the entrance to Cherbourg Harbour. (Britton Collection)

⌃ Viewed from the forward observation lounge, the *Elizabeth* has passed the Dique de Homet in Cherbourg and approaches the Grande Terminal from where passengers can continue their journey across Europe. (Britton Collection)

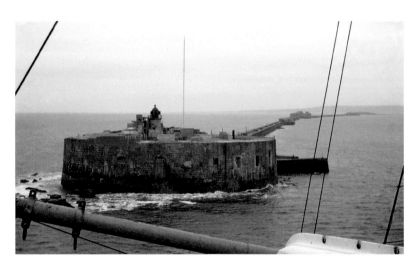

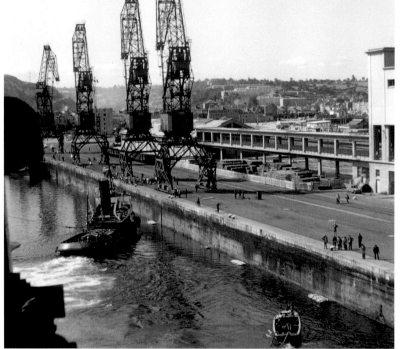

⌃ The harbour entrance at Cherbourg, viewed from *Queen Elizabeth*. (Arthur Oakman/Britton Collection)

❯ A French tug hauls the *Elizabeth* alongside the quay at Cherbourg. Note the harbourmaster's launch off the starboard bow with a securing line, 27 April 1968. (Britton Collection)

^ From a porthole on the port side of the *Elizabeth* one can see the French tugs busy manoeuvring the liner alongside the quay at Cherbourg, 27 April 1968. (Britton Collection)

❯ Organised chaos on the quayside at Cherbourg as the passenger luggage is transferred to *Elizabeth* on 27 April 1968. (Britton Collection)

^ With portable gangway No. 3 safely in position, a second gangway is directed to the quayside-level access door and telescoped towards the *Elizabeth* at Cherbourg, 27 April 1968. (Britton Collection)

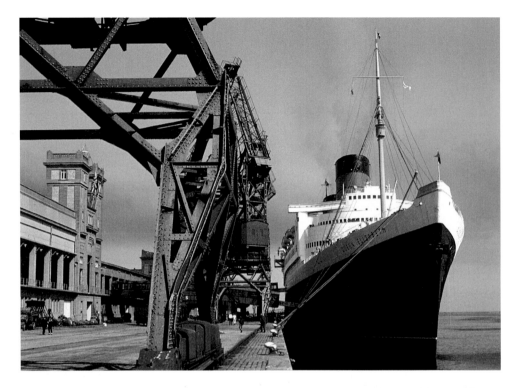

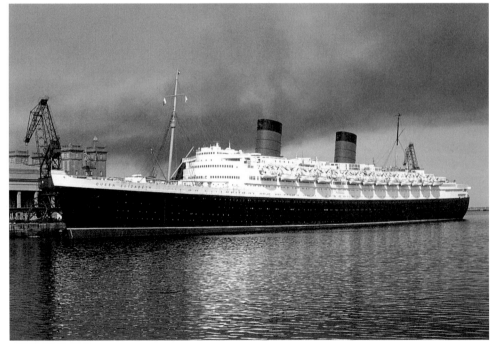

❬ Dawn interlude at Cherbourg. The *Elizabeth* simmers in the sunshine on 27 April 1968. (Britton Collection)

❭ With a nod from Captain Jean Burel, the Cherbourg Harbour pilot, Commodore Marr hails Senior First Officer Gossett from the bridge: 'Let go fore and aft!' (Britton Collection)

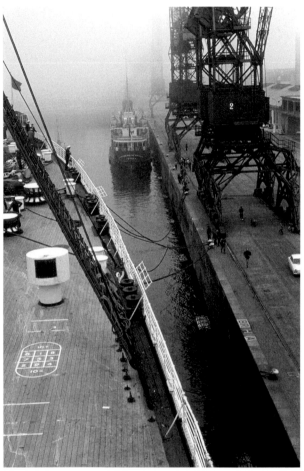

❬ *Paquebot majestueux à Cherbourg* on 27 April 1968. (Britton Collection)

❯ On the boat deck, the sun has come out to dry up the wooden deck and reveal pleasant calm blue seas. (Arthur Oakman/Britton Collection)

⌄ The Cherbourg tug responds to the *Elizabeth*'s three whistles and takes the strain to haul the ship astern into the Grande Rade for turning prior to departure. Deckhands wrestle the fibre ropes at the aft end of the ship. (Britton Collection)

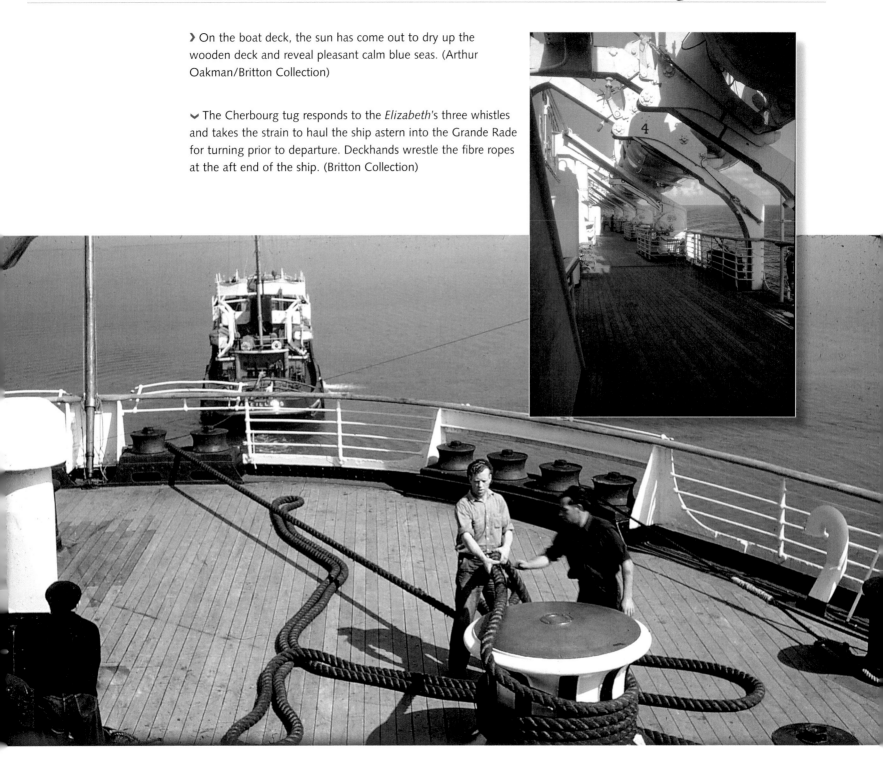

‹ A first-class accommodation leaflet. (Britton Collection)

⌄ The cover of a passenger list. (Britton Collection)

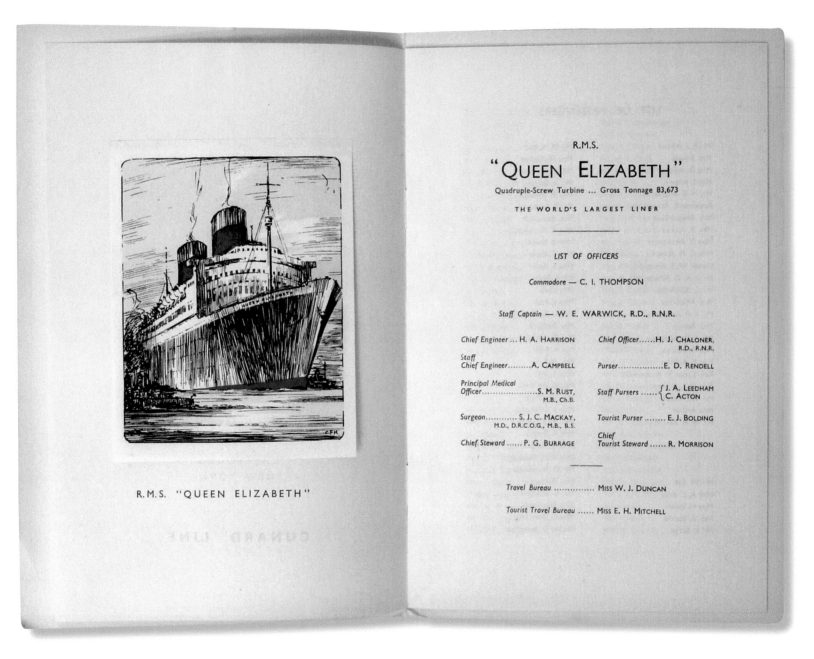

R.M.S. "QUEEN ELIZABETH"

R.M.S.

"QUEEN ELIZABETH"

Quadruple-Screw Turbine ... Gross Tonnage 83,673

THE WORLD'S LARGEST LINER

LIST OF OFFICERS

Commodore — C. I. THOMPSON

Staff Captain — W. E. WARWICK, R.D., R.N.R.

Chief Engineer ... H. A. HARRISON	Chief Officer......H. J. CHALONER, R.D., R.N.R.
Staff Chief Engineer.........A. CAMPBELL	Purser.................E. D. RENDELL
Principal Medical Officer......................S. M. RUST, M.B., Ch.B.	Staff Pursers { J. A. LEEDHAM C. ACTON
Surgeon...........S. J. C. MACKAY, M.D., D.R.C.O.G., M.B., B.S.	Tourist Purser E. J. BOLDING
Chief Steward P. G. BURRAGE	Chief Tourist Steward R. MORRISON

Travel Bureau MISS W. J. DUNCAN

Tourist Travel Bureau MISS E. H. MITCHELL

⌃ A list of officers. (Britton Collection)

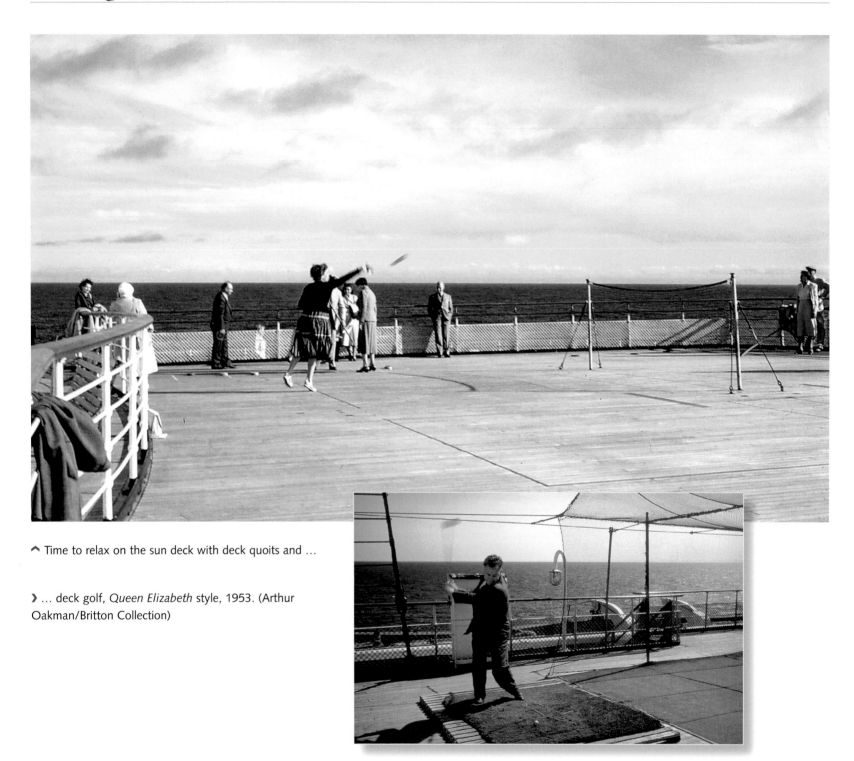

⌃ Time to relax on the sun deck with deck quoits and …

❯ … deck golf, *Queen Elizabeth* style, 1953. (Arthur Oakman/Britton Collection)

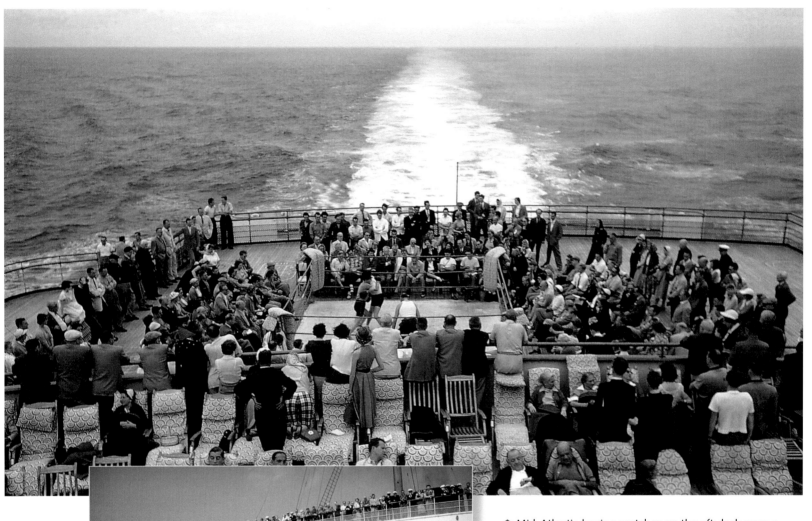

⌃ Mid-Atlantic boxing matches on the aft deck were a popular pastime on *Queen Elizabeth*, and some passengers in the tourist class chose to sunbathe in their open shirts, in contrast to the smartly dressed cabin- and first-class passengers. (Arthur Oakman/Britton Collection)

❮ A smiling Commodore Marr and other officers have a ringside seat to watch the action. Several other members of staff are seen watching from the top-deck railings. (Arthur Oakman/Britton Collection)

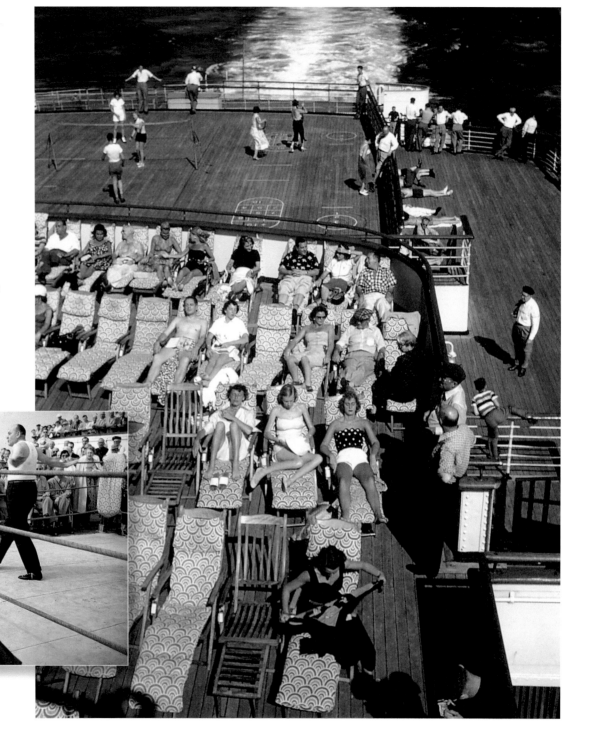

❯ Mid-Atlantic on the aft sun deck in 1953, caressed by sunshine and salty winds. Note the deck tennis and quoits game in action. (Arthur Oakman/Britton Collection)

❮ It's a knock out! (Arthur Oakman/Britton Collection)

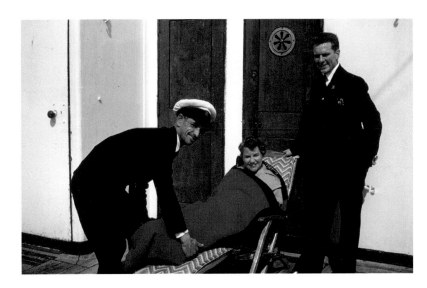

^ Pure comfort. Staff took great pride in ensuring the passengers' needs were catered for down to the last whim and fancy. (Arthur Oakman/Britton Collection)

^ Lifeboat drill on *Queen Elizabeth* in 1953. (Arthur Oakman/Britton Collection)

^ The main lounge, showing the painting by Sir Oswald Birley of Her Majesty Queen Elizabeth, the Queen Mother. The walls were mostly panelled with Canadian maple burr finished to a delicate tawny pink. (Ernest Arroyo/Britton Collection)

^ The gala dinner for the famous pianist Liberace, complete with a pink-coloured grand piano cake. (Britton Collection)

^ The cabin-class restaurant was 104ft long, 63ft wide and accommodated 377 diners at one sitting. (Cunard/Britton Collection)

ⴸ The gym on board the *Elizabeth*. (Britton Collection)

ⴸ The indoor swimming pool. (Britton Collection)

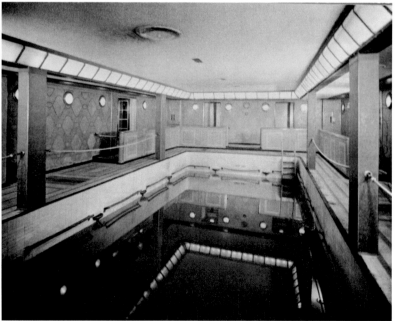

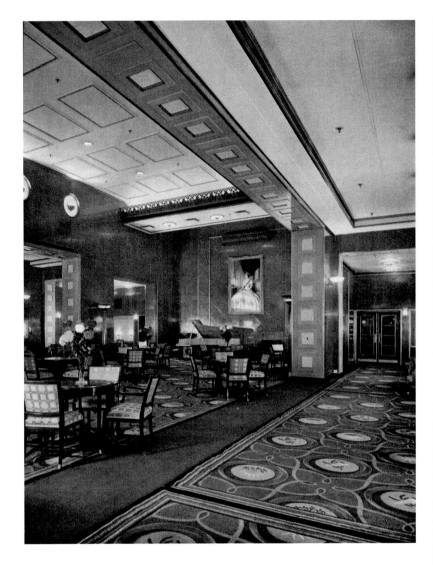

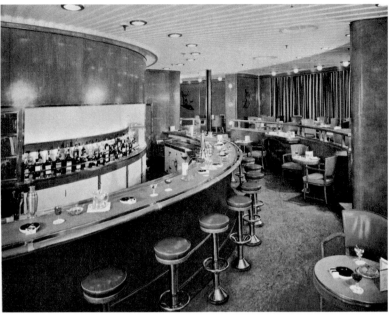

^ The observation lounge. (Britton Collection)

^ The main lounge. (Britton Collection)

> The smoking room. (Britton Collection)

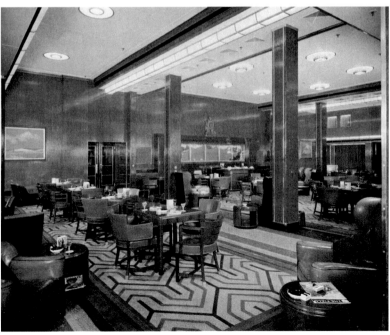

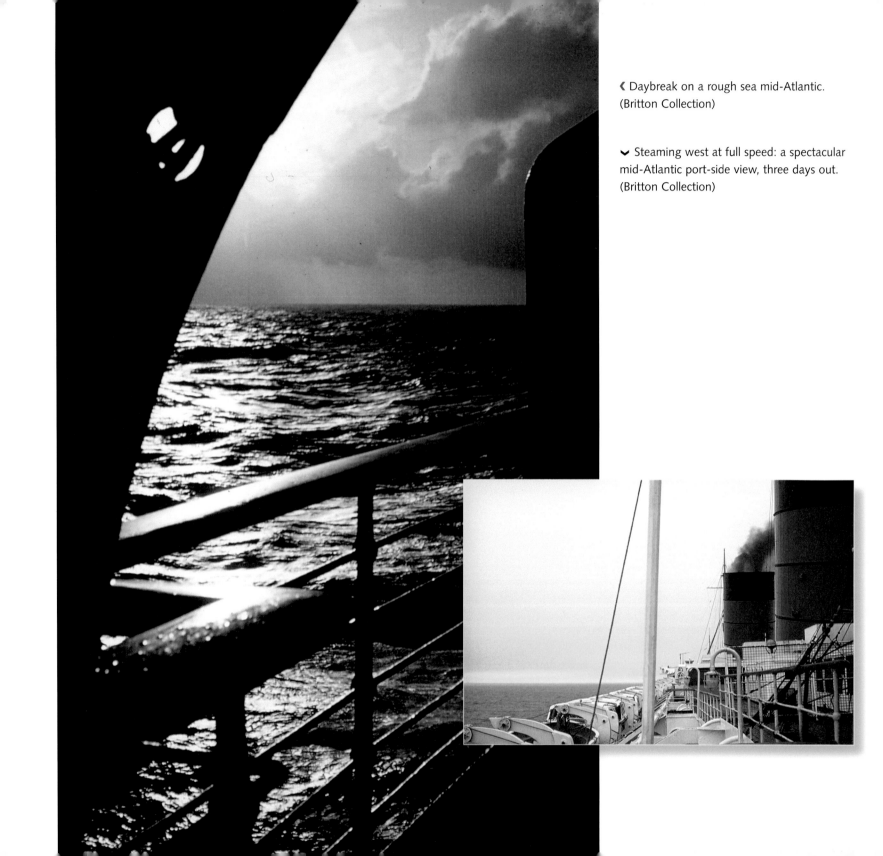

❮ Daybreak on a rough sea mid-Atlantic. (Britton Collection)

❯ Steaming west at full speed: a spectacular mid-Atlantic port-side view, three days out. (Britton Collection)

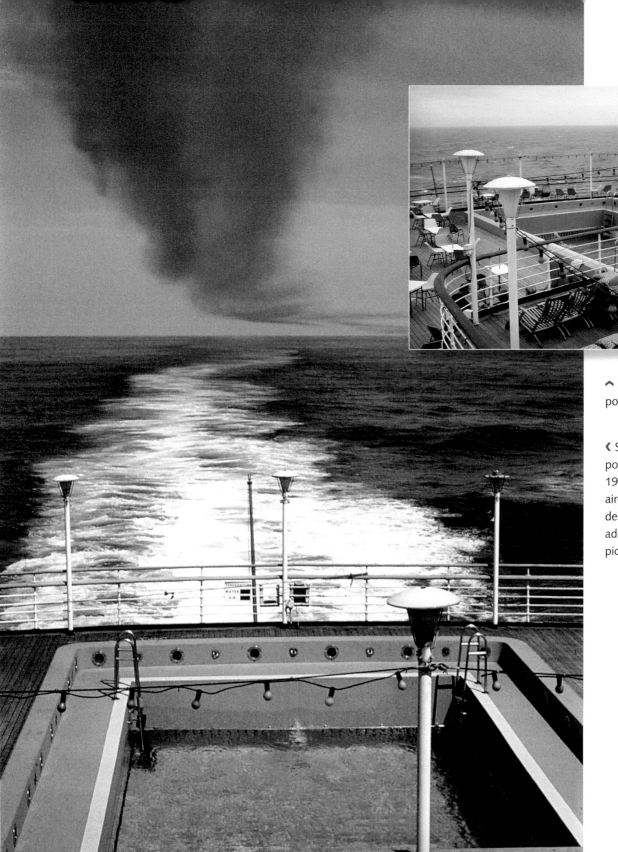

∧ A close-up of the aft swimming pool in 1968. (Britton Collection)

❮ Smoke, wake and the aft swimming pool, mid-Atlantic in 1968. In 1966 she had been completely air-conditioned and had a new lido deck with an outdoor swimming pool added to the stern, as shown in this picture. (Britton Collection)

Menu covers. (Britton Collection)

R.M.S. "Queen Elizabeth"
COMMODORE G. T. MARR, D.S.C., R.D., (Cr. R.N.R. Rtd.)

WEST INDIES CRUISE
CRUISE DIRECTOR: HAROLD M. GRIMES

For Ship's Notices and Movies — Please see reverse side of Programme
Suggested Dress this Evening: Straw Hat, Coloured Shirt or Lei (otherwise formal)

★ ★

For Your Entertainment :

Today's Quiz — "A, B or C Competition"

7.00 a.m. to 7.00 p.m.—Swimming Pools available Lido Deck & 'R' Deck Fwd.
7.00 a.m. to 7.00 p.m.—Gymnasium available Sun Deck Forward
7.00 a.m.—Squash Court open Sun Deck
9.00 a.m.—Juke Box, Bowling Alley, Soccer Playtable available The 'Cavern'
9.00 a.m.—Deck Sports and Table-Tennis Open Decks and Main Deck Aft.
10.00 a.m.—**Come Up For Air !**
Time again to meet the Cruise Staff on Promenade Deck Square Forward for a Deck Hike (followed by Keep-Fit Class)
10.00 a.m. to 3.00 p.m.—**Some Shackle !**
The Mooring Shackle displayed on Promenade Deck is heavy. Now you tell us just how heavy (in ounces) and the prize is yours.
10.00 a.m.—Informal instruction in Squash Squash Court
10.30 a.m.—**Scavenger Hunt (Prizes)** Starboard Garden Lounge
Come along and get your list of items to be collected and see how many you can produce by Noon.
11.00 a.m.—Another Dance Class "Queen Elizabeth" Lounge
The Trio Vitalites continue their free lessons
10.30 a.m.—Hostess Session Port Garden Lounge
Ladies, come along for coffee and a chat with Shirley, Jane and Maureen.
11.00 a.m.—Health and Beauty Culture Exercises for Ladies Gymnasium
11.15 a.m.—Totalisator on the Ship's Run Promenade Deck Square
Can you guess how many miles the ship has travelled since leaving Martinique?
11.30 a.m.—**Second Gymkhana (Prizes!)**
Come along to the Lido Deck and join in another session of amusing games on deck
11.45 a.m.—News Broadcast Midships Bar and Caribbean Room
Noon to 1.00 p.m.—Cocktail Time with Malcolm MacLean Midships Bar
Noon to 1.00 p.m.—"Queen Elizabeth" String Combo Club Room Cocktail Bar
Noon to 1.00 p.m.—Ray Baines at the Piano Observation Bar
12.30 to 2.00 p.m.—**Deck Buffet Luncheon** Promenade Deck, Starboard Side
2.45 p.m.—Bridge Party (Prizes !) Smoke Room
2.45 p.m.—Scrabble Tournament (Prizes!) Club Room
2.45 p.m.—Recorded Concert "Queen Elizabeth" Lounge
Quartet in C Major, K.465, and Quartet in D Major, K.575 (Mozart)
The Amedeus String Quartet
3.45 p.m.—**Tea Dance** Caribbean Room
to the music of Jack Duff and his Beachcombers
3.45 p.m.—Tea-Time Melodies "Queen Elizabeth" Lounge
5.00 p.m.—**Table Tennis Final** "Queen Elizabeth" Lounge
and Presentation of Prizes to Deck Sports Tournament Winners
6.00 p.m.—News Broadcast "Queen Elizabeth" Lounge, Midships Bar and Caribbean Room

**FRIDAY
JANUARY 13
1967**

The Observation Bar
(7.00 to 8.00 p.m. — Ray Baines at the Piano)
The Midships Bar
(7.00 to 8.00 p.m. — Dancing to the music of Malcolm MacLean on the Cordovox)
Club Room Cocktail Bar
(7.00 to 8.00 p.m. — The Barry Elton Trio)
The Caribbean Room
(7.00 to 8.00 p.m. — The Jack Duff Combo)
The Smoke Room

Cocktail Time
This Evening

Your Choice Of
Rendezvous

TONIGHT . . .

in the "Queen Elizabeth" Lounge

8.45 p.m.—Ray Baines at the Organ
9.30 p.m.—**Bingo !**
Interludes by Ray Baines
followed at 10.30 p.m. by
BEACHCOMBER BALL AND CABARET
Dancing to the music of Horace Galey and his Beachcombers
with Cabaret at 10.45 p.m.
featuring
Nancy Howe Bobbie Baker
Delage and Magaret

★ ★

in the Midships Bar

From 9.30 p.m.

DANCING to the music of Malcolm MacLean
on the Cordovox
and Cabaret Entertainment by
The Paul Gene Trio

★ ★

in the Caribbean Room

From 10.00 p.m.

Entertainment by **The Applejacks**
and **DANCING**
to the music of Jack Duff's Beachcombers

★ ★

in the Verandah Grill

From 11.00 p.m. — DANCING
to the music of the Barry Elton Trio

A Buffet Supper will be served from 11.00 p.m. to 1.00 a.m.

^ A programme for the West Indies Cruise. (Britton Collection)

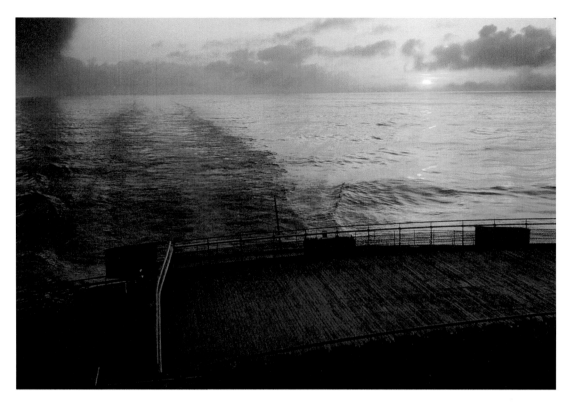

☞ Sunset from the stern of *Queen Elizabeth* in 1953. (Arthur Oakman/Britton Collection)

⌃ Perfectly framed from the starboard lifeboat deck is the eastbound Cunard RMS *Mauretania* bound for Cobh and Southampton. (Britton Collection)

❮ *Queen Elizabeth* is about to head under the Verrazano Bridge before entering the Narrows at the entrance to New York Harbor. Just ahead of the ship in the hazy mist, in Upper New York Bay, is SS *United States*. (Britton Collection)

⌃ 'Now I know we are home,' cries out an excited American passenger aboard *Queen Elizabeth* in 1953 as he spots the Statue of Liberty in New York Harbor. (Arthur Oakman/Britton Collection)

❭ A sparkling *Queen* heads up the tidal seaway of the Hudson River in New York. (Britton Collection)

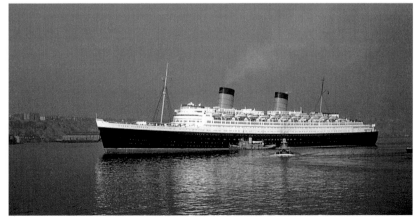

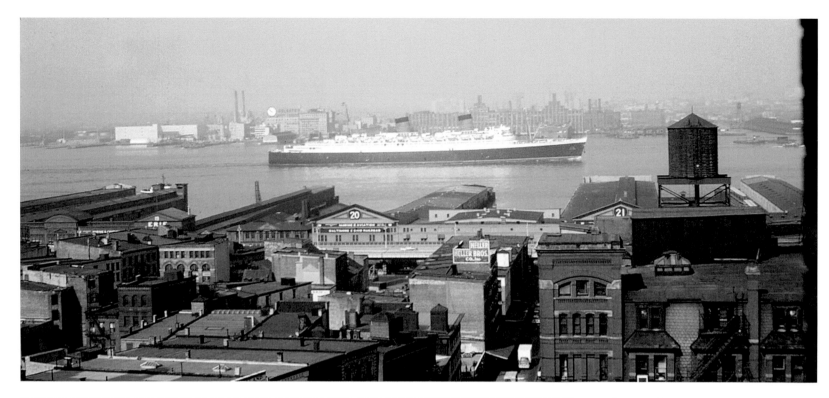

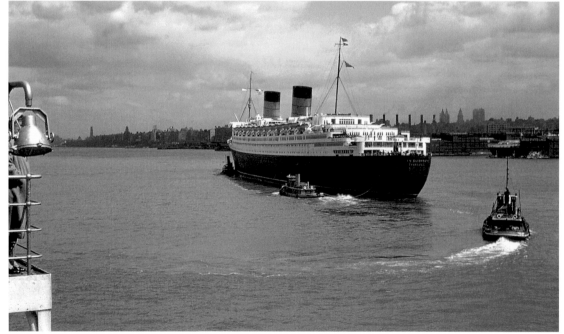

⌃ After completing yet another Atlantic crossing, *Queen Elizabeth* gently sails up the Hudson providing onlookers with a scintillating sight as she glides past the piers. (Britton Collection)

❮ Photographed from the deck of the French Line SS *Île de France*, the *Elizabeth* is seen heading up the Hudson River towards Pier 90. (Britton Collection)

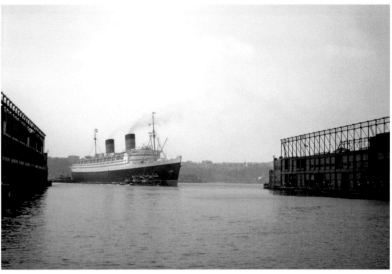

^ The North German Lloyd Line *Bremen* is seen resting at Pier 88 West 48th Street in New York as *Queen Elizabeth* sails up the Hudson towards Pier 92 at West 52nd Street. (Bill Cotter)

^ Gently does it. Three Moran tugs are buffered into the starboard bow and two further Moran tugs are pushing at the starboard stern position to manoeuvre *Queen Elizabeth* into Pier 92. The currents of the Hudson River at this point were very strong and hazardous. (Bill Cotter)

‹ *Queen Elizabeth*, sailing up the Hudson River towards Pier 90, passes the Cunard *Britannic*, the last ship built for the White Star Line. (Britton Collection)

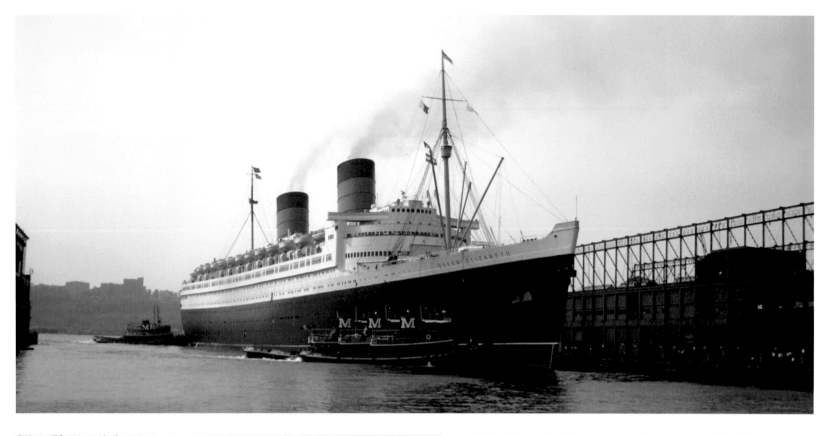

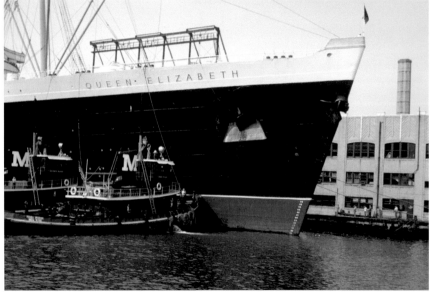

∧ With the worst of the manoeuvring now complete, *Queen Elizabeth* is pushed alongside into Pier 92 at New York. (Bill Cotter)

❮ Job almost done. The Moran tugs *Moira Moran* and *Barbara Moran* hold the enormous bow of *Queen Elizabeth* firm into Pier 92 while mooring lines are secured. (Bill Cotter)

❯ Soon after arrival on 30 April 1968, *Queen Elizabeth* is approached by a crane mounted on a barge, possibly to unload a car stowed on deck. Her superstructure towers high above the water. (Ringo Viscarci)

❮ Luxury Liner Row with an impressive parade of liners, including: RMS *Queen Elizabeth*, SS *United States*, SS *America* and the SS *Leonardo da Vinci*. (Bill Cotter)

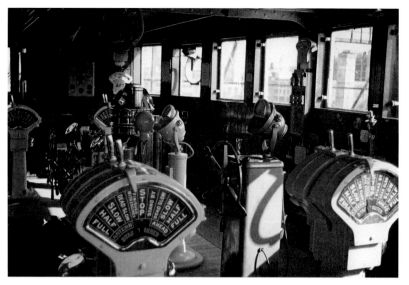

^ The bridge of *Queen Elizabeth* when docked in New York. (Britton Collection)

^ A superb aerial view of an impressive line-up at the New York piers. *Queen Elizabeth* is at Pier 92 and SS *United States* is at Pier 86, but in between are two aircraft carriers and three US Navy destroyers. (Britton Collection)

v The Moran tug *Barbara Moran I* is seen pushing hard at the bow of *Queen Elizabeth* to inch her into Pier 90 at New York. Meanwhile, cars race across the flyover at West 51st Street. (Britton Collection)

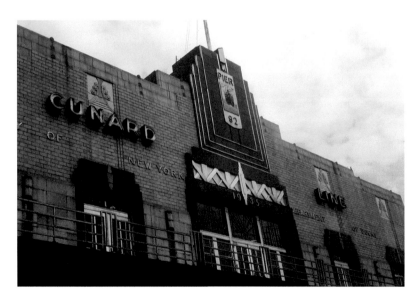

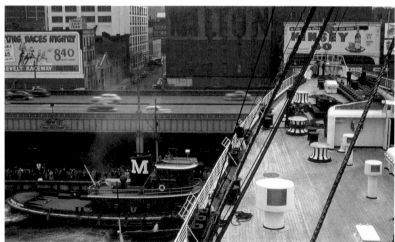

❮ Journey's end. The exterior of the Cunard Pier 92 building which was built in 1935. (Britton Collection)

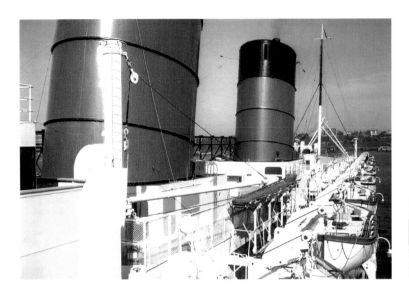

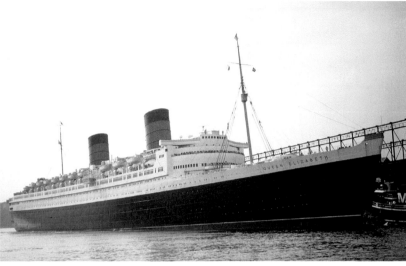

⌃ Majestic symbols: the *Elizabeth*'s twin funnels rise 70ft above the sun deck as one looks astern down the port side from the bridge wing across the Hudson River. (Richard Weiss)

⌐ *Queen Elizabeth*, assisted by Moran tugs, prepares to sail for Europe from Pier 92 in New York; next stop, Cherbourg. (Ernest Arroyo/David Boone Collection)

❯ Night-time at Pier 92 with a New York City Police Department patrol car parked in front of *Queen Elizabeth*. Her illuminated funnels glow in the darkness like a massive advertisement for Cunard. (Britton Collection)

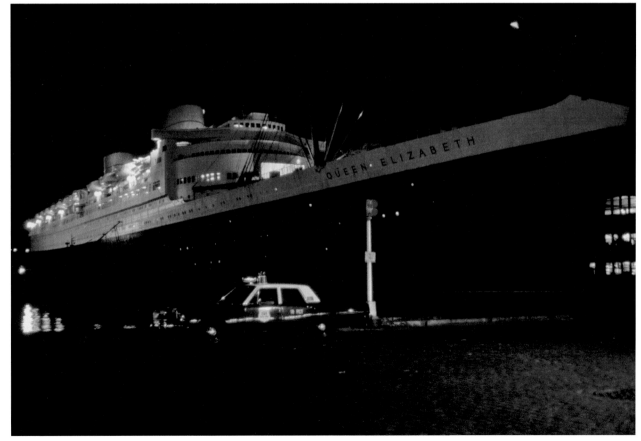

Cunard Line

APERITIFS

	Per Glass
Amer Picon (with Soda Water) ..	2/–
Vodka	2/–
Aalborg Akvavit	2/–
Gin and Vermouth	2/–
Gin and Bitters	1/9
Sherry and Bitters ..	1/6
Mixed Vermouth	1/6
Vermouth, Italian, Martini Rossi	1/6
Vermouth, French, Noilly Prat ..	1/6
Vermouth, French, Rozes ..	1/6
Dubonnet	1/6
Kina Lillet	1/6
Fernet Branca	1/6

COCKTAILS

Champagne

Liqueurs

	Per Liq. Glass
Denis Mounié Cognac, 1865 ..	3/6
Courvoisier Napoleon (80 years old)	3/6
Martell Extra (Guaranteed over 70 years old)	3/6
Gautier Frères, Cognac (70 years old)	3/6
Bisquit Dubouché Cognac, Extra	2/6
Hennessy Cognac, X.O. ..	2/6
Monnet Cognac, 40 years old	2/6
Remy Martin Cognac, V.S.O.P. ..	2/6
Martell Cognac, Cordon Bleu ..	2/6
Hine Cognac, V.V.S.O.P. ..	2/6
Denis Mounié, V.V.S.O.P. ..	2/6
Chartreuse, Yellow	2/–
Chartreuse, Green	2/–
Bénédictine, D.O.M.	2/–
Drambuie	2/–
Grand Marnier	2/–
Crème de Menthe, Green ..	2/–
Crème de Menthe, White ..	2/–
Cointreau	2/–
Kümmel	2/–
Curaçao, Triple Dry	2/–
Cherry Heering	2/–
Crème de Cacao	2/–
Peach Brandy	2/–
Apricot Brandy, Apry	2/–
Sloe Gin	2/–
Calvados	2/–
Van Der Hum	2/–

MIXED DRINKS

	Per Glass
Egg Nogg, Brandy	2/9
Egg Nogg, Whisky	2/3
Egg Nogg, Port	2/–
Egg Nogg, Sherry	1/9
Sherry Flip	1/9
Whisky Flip	2/3
Brandy Flip	2/9
Pimm's No. 1	2/6
Gin Sling	2/3
Clover Club	2/3
Gin Rickey	2/3
Gin Fizz	2/3
Silver Fizz	2/6
Golden Fizz	2/6
Royal Fizz	2/6
Whisky Sour	2/6
Tom Collins	2/6
John Collins	2/6
Rum Collins	2/9
Cuba Libre	3/3
Sherry Cobbler	2/–
Morning Glory	2/9
Planters Punch	2/9

SHOPPING LIST

Cunard

⌃ The *Elizabeth*'s cocktail bar price list. (Britton Collection)

❮ A shopping list. (Britton Collection)

> Post-war Atlantic sailings.
(Britton Collection)

˅ An invitation from the cruise director.
(Britton Collection)

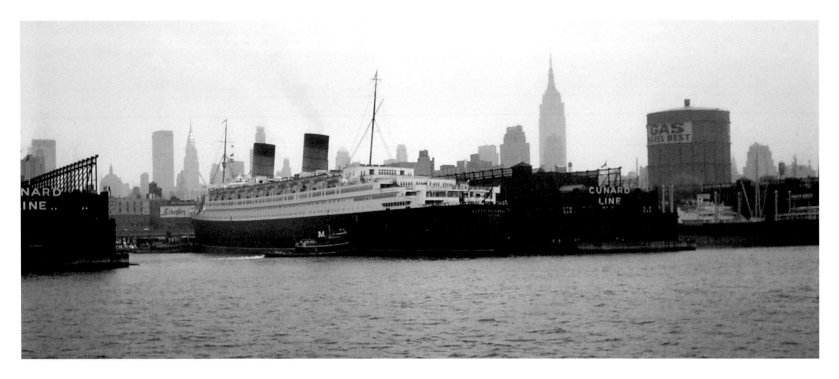

∧ Departure from Pier 90 at New York in July 1963. (Britton Collection)

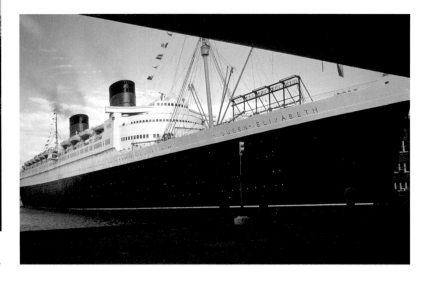

∧ A view from the starboard side of *Queen Elizabeth* at Pier 92 in New York, showing the portable gangways connected ready for the final departure, 1968. The New York dockworkers have decorated Pier 92 in complete contrast to her final departure from Southampton. (Britton Collection)

∧ Steam is being raised for departure from Pier 92 at New York, as the smoke from the funnels testifies. (Ernest Arroyo/David Boone Collection)

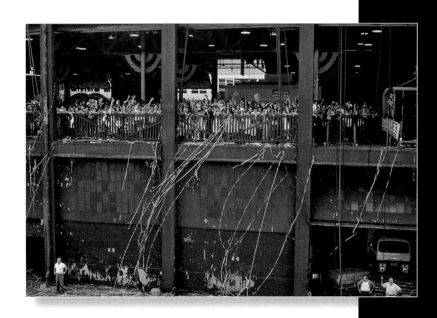

∧ A rapturous farewell. Well-wishers with streamers wave and cheer their enthusiastic goodbyes as *Queen Elizabeth* departs from New York for the last time in 1968. Commodore Marr recalls that they shouted: 'Sorry to see you go, *Queen Elizabeth*.' (Britton Collection)

❯ The *Elizabeth* is gently pushed out into the Hudson River by a Moran tug. (Bill Cotter)

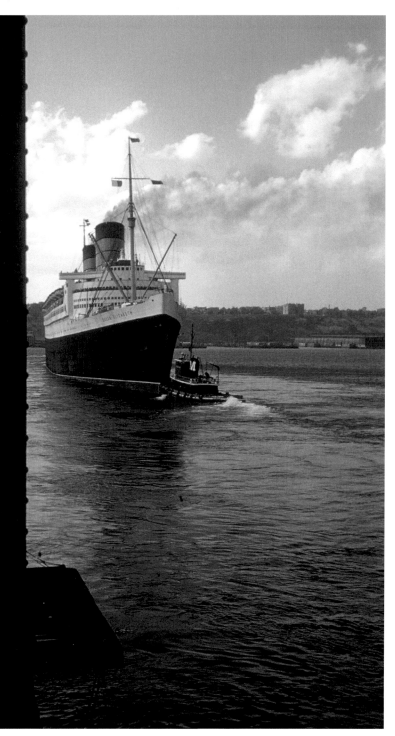

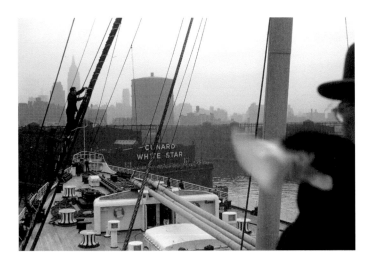

○ As the *Elizabeth* begins to move astern from Pier 92, deckhands tie down the rigging on the forward mast. Cheering and waving crowds watch from the end of the pier. (Arthur Oakman/Britton Collection)

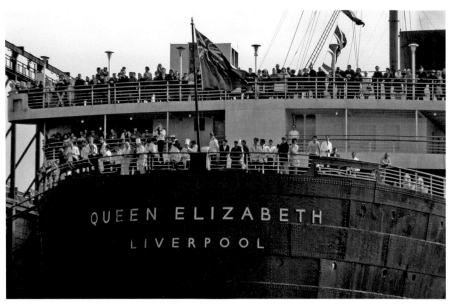

⌃ The final departure of *Queen Elizabeth* from Pier 92 at New York in 1968, photographed from a Moran tug. The deck railings are packed with passengers; even the liner's cooks and stewards have come out on deck for the last sailing from New York on 30 October 1968. (Ernest Arroyo/Britton Collection)

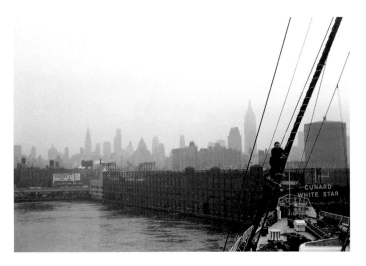

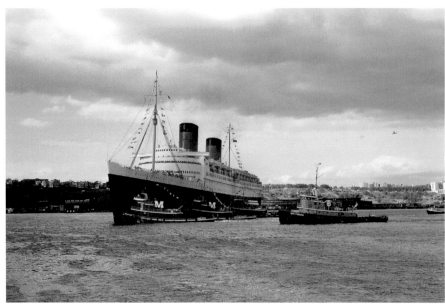

❯ The *Elizabeth* in the Hudson River, 30 October 1968. (Ernest Arroyo/David Boone Collection)

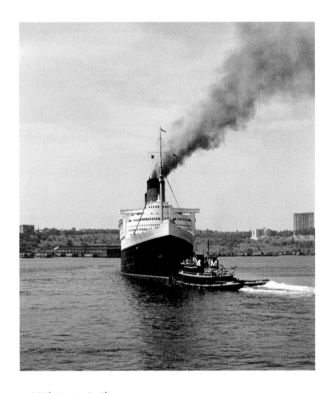

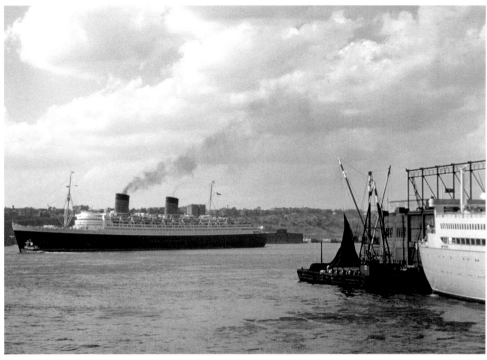

^ Midstream in the Hudson and the brace of Moran tugs are working hard to manoeuvre the liner and point her towards the Atlantic. (Britton Collection)

^ A lone Moran tug completes the task of pushing the bow of *Queen Elizabeth* in the Hudson River. (Bill Cotter)

❮ Manhattan from the decks of the *Elizabeth* as she heads down the Hudson River. Passengers feel the thrill of being under way, having stepped from the bustle of New York's city streets into a floating hotel with ever-changing, breathtaking views. (Britton Collection)

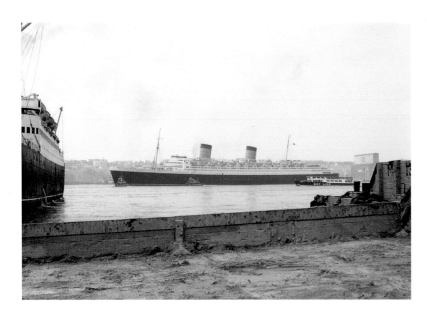

˄ Heading down the Hudson River, *Queen Elizabeth* is escorted by a Day Line pleasure boat packed with sightseers. (Britton Collection)

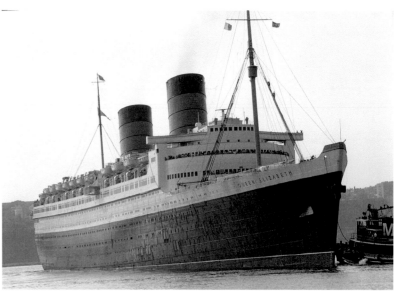

˄ *Queen Elizabeth* is now midstream on the Hudson River and about to set off solo towards the Narrows. The light has captured every porthole and rivet on her starboard side. (Ernest Arroyo/David Boone Collection)

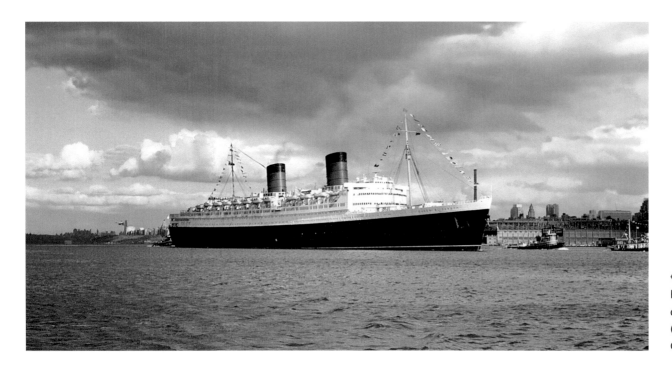

❮ *Queen Elizabeth* in the Hudson River on her final departure from New York. (Ernest Arroyo/David Boone Collection)

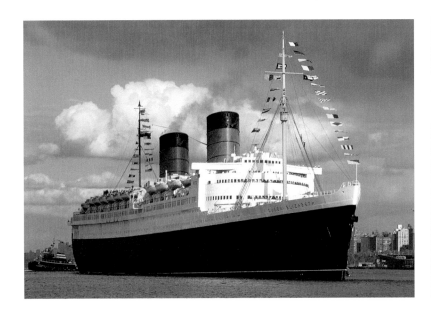

∧ The *Elizabeth*'s paying-off pennant streams out in the stiff breeze on her port side. (Ernest Arroyo/David Boone Collection)

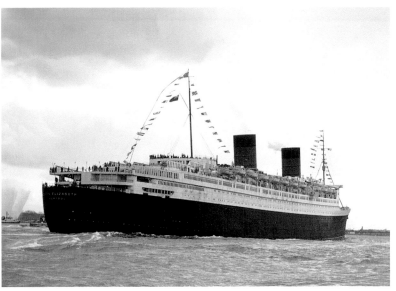

∧ Riding in the wake of *Queen Elizabeth* down the Hudson River, 30 October 1968. (Ernest Arroyo/David Boone Collection)

❯ *Queen Elizabeth* sails from Pier 92 at New York. This photograph was taken from Weehawken looking across the Hudson River from the Alexander Hamilton monument. Berthed at Pier 86 are the United States Line's SS *United States* and SS *America*. (Britton Collection)

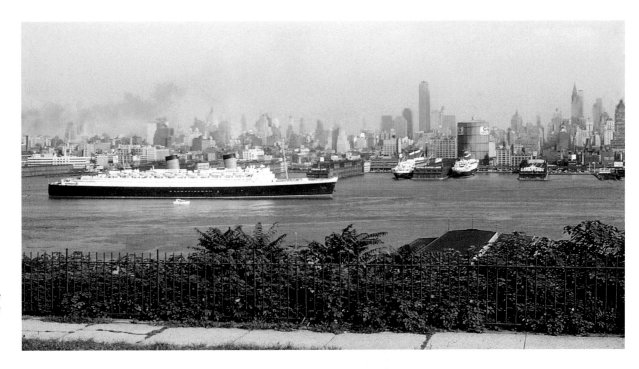

> An Atlantic sailings brochure. (Britton Collection)

˅ A Mediterranean Cruise brochure, 1964. (Britton Collection)

^ A Bermuda Cruise brochure. (Britton Collection)

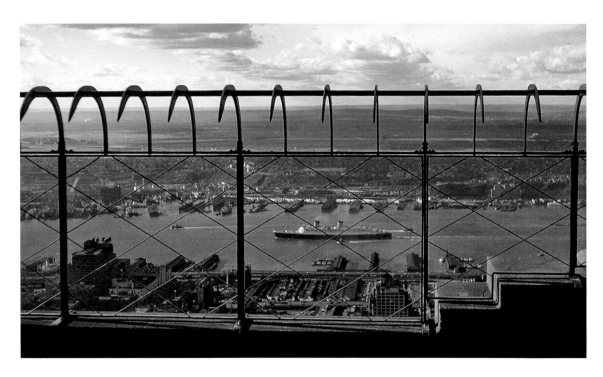

❮ A view of the *Elizabeth* heading along the Hudson in 1958, taken through the railings at the top of the Empire State Building. (Britton Collection)

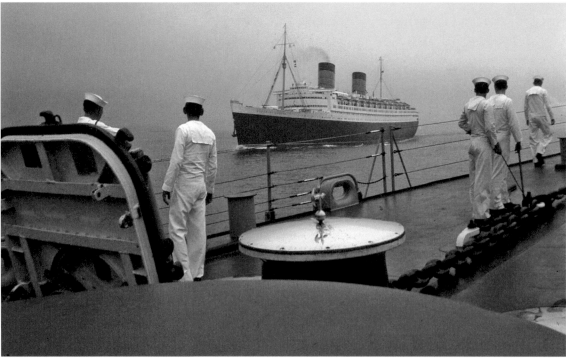

❮ Sailors on board a US Navy vessel pause from their duties to watch *Queen Elizabeth* pass by on the Hudson River before she heads out into the Atlantic, 14 July 1964. (Britton Collection)

❯ Atlantic departure. The *Elizabeth*, with her long paying-off pennant, sails past the Statue of Liberty for the last time. (Ernest Arroyo/ Britton Collection)

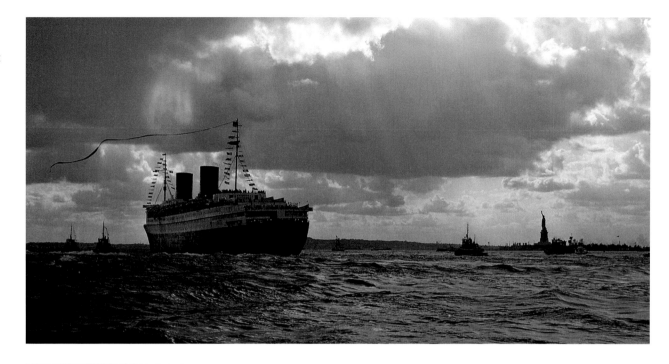

❯ *Queen Elizabeth* is anchored off Nassau while on a Caribbean cruise. Berthed in the foreground is the American Export Line ship SS *Constitution*. (Britton Collection)

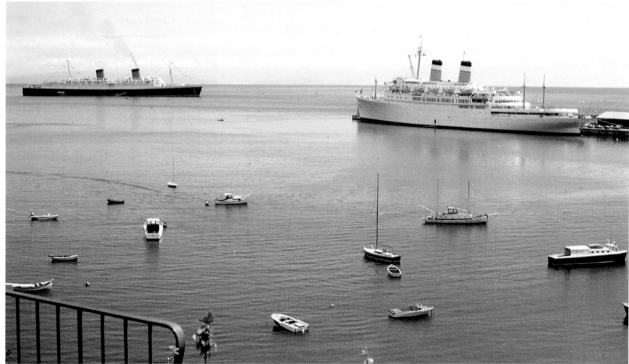

Queen Elizabeth in retirement at Port Everglades, Florida. (Britton Collection)

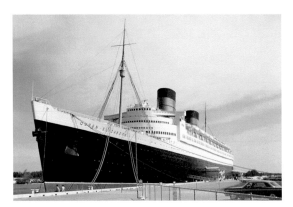

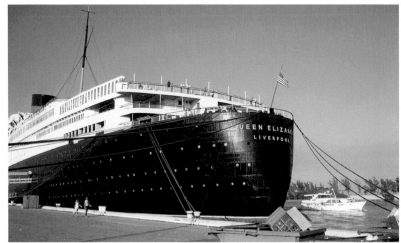

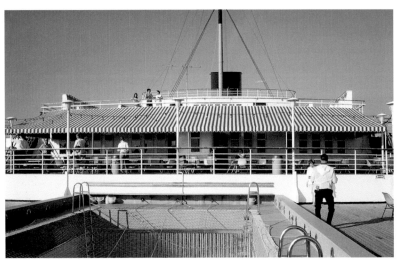

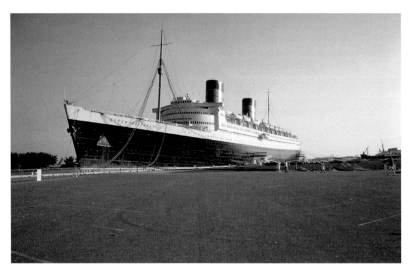

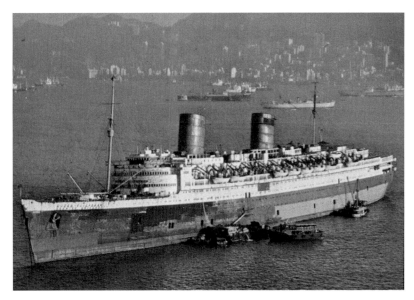

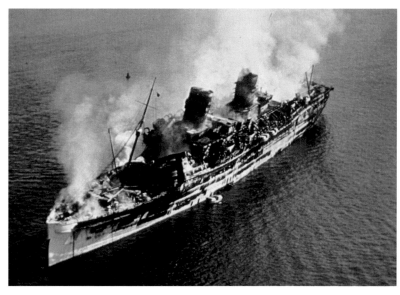

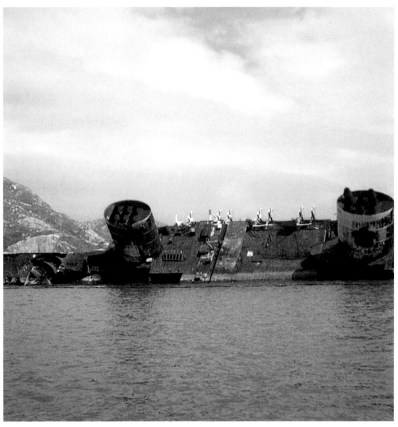

r *Seawise University* is seen undergoing her ill-fated refit and conversion in Hong Kong Harbour. (World Ship Society)

ʌ The death of a great liner as the steel work collapses on the now-smouldering wreck. (World Ship Society)

❮ And gone forever. The scorched, charred, rusting remains of the once pride of the Atlantic. She was now only fit for a final appearance as a set location for a James Bond film. (Britton Collection)

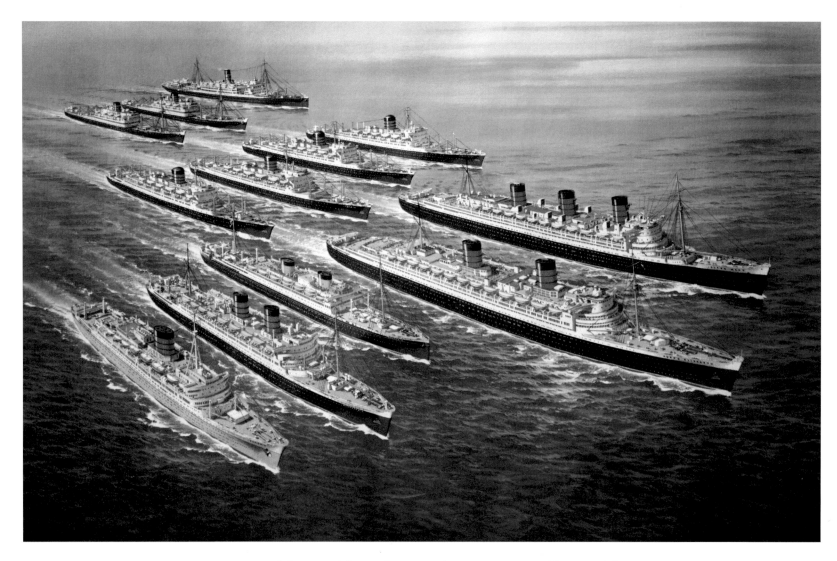

⌃ Canvas painting of the Cunard fleet in the 1950s. This painting was used by Cunard for publicity purposes and was hung on the wall of the Cunard Pier 92 until 1968. It shows the Cunard flagship, RMS *Queen Elizabeth*, at the head of the fleet. (Britton Collection)